Role Models

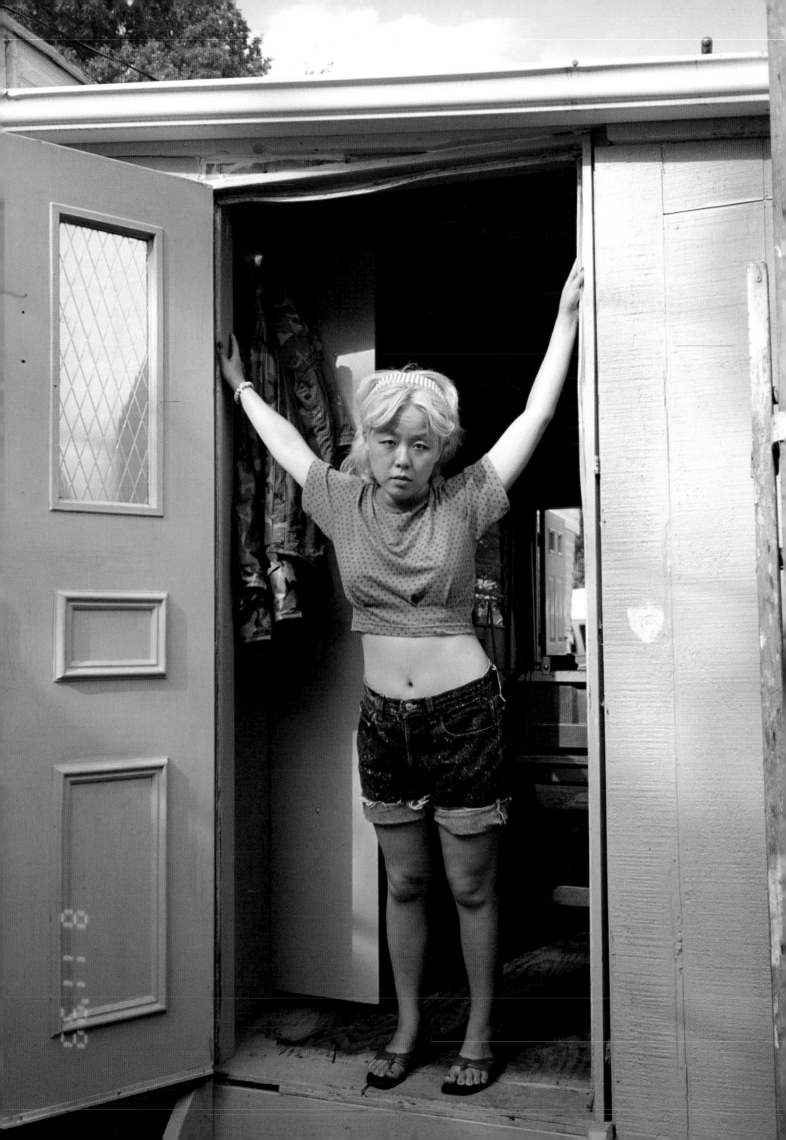

Role Models

Feminine Identity in Contemporary American Photography

National Museum of Women in the Arts, Washington, D.C.,
in association with Scala Publishers Limited, London

SCALA

Cover: Anna Gaskell, *untitled #6 (wonder)*, 1996.
Heather and Tony Podesta Collection, Washington, D.C.

Frontispiece: Nikki S. Lee, *The Ohio Project (8)*, 1999.
Heather and Tony Podesta Collection, Washington, D.C.

All measurements are in inches; height precedes width
precedes depth.

Publication coordinated by Amy Pastan
Edited by Suzanne G. Fox, Red Bird Publishing, Inc.,
Bozeman, MT
Designed by Katy Homans
Produced by Scala Publishers Limited, London
Printed in China

First published in 2008 by
Scala Publishers Limited
Northburgh House
10 Northburgh Street
London EC1V 0AT
United Kingdom

Distributed outside the participating venues in the
book trade by
Antique Collectors' Club Limited
Eastworks
116 Pleasant Street, Suite 60B
Easthampton, MA 01027
United States of America

ISBN: 978-1-85759-538-3 (hardback)
ISBN: 978-1-85759-572-7 (softback)

Role Models

Feminine Identity in Contemporary American Photography

NATIONAL MUSEUM OF WOMEN IN THE ARTS

Washington, D.C.

October 17, 2008—January 25, 2009

THIS EXHIBITION HAS BEEN ORGANIZED BY

THE NATIONAL MUSEUM OF WOMEN IN THE ARTS (NMWA), WASHINGTON, D.C.

Thank you to Lois Lehrman Grass and NMWA's Business and Professional Women's
Council for their lead sponsorship of *Role Models: Feminine Identity in Contemporary
American Photography*. Generous support also has been provided by the National
Endowment for the Arts.

NATIONAL
ENDOWMENT
FOR THE ARTS
A great nation
deserves great art.

EXHIBITION CURATORS

Susan Fisher Sterling, Director

Kathryn A. Wat, Curator of Modern and Contemporary Art

CATALOGUE CONTRIBUTORS

Shelley Rice

Lucy Soutter

Susan Fisher Sterling

Kathryn A. Wat

EXHIBITION ARTISTS

Eleanor Antin	Mary Ellen Mark
Tina Barney	Catherine Opie
Anna Gaskell	Barbara Probst
Nan Goldin	Collier Schorr
Katy Grannan	Cindy Sherman
Justine Kurland	Laurie Simmons
Nikki S. Lee	Lorna Simpson
Sharon Lockhart	Angela Strassheim
Sally Mann	Carrie Mae Weems

Contents

PREFACE

Susan Fisher Sterling

7

ENIGMATIC SPECTACLE: KEY STRATEGIES IN CONTEMPORARY STAGED PHOTOGRAPHY

Lucy Soutter

11

CROSSCURRENTS: MODELS, MIGRATIONS, AND MODERNISMS

Shelley Rice

23

FASHIONING FEMININE IDENTITY IN CONTEMPORARY AMERICAN PHOTOGRAPHY

Susan Fisher Sterling and Kathryn A. Wat

35

PLATES

45

ARTIST BIOGRAPHIES

129

EXHIBITION CHECKLIST

132

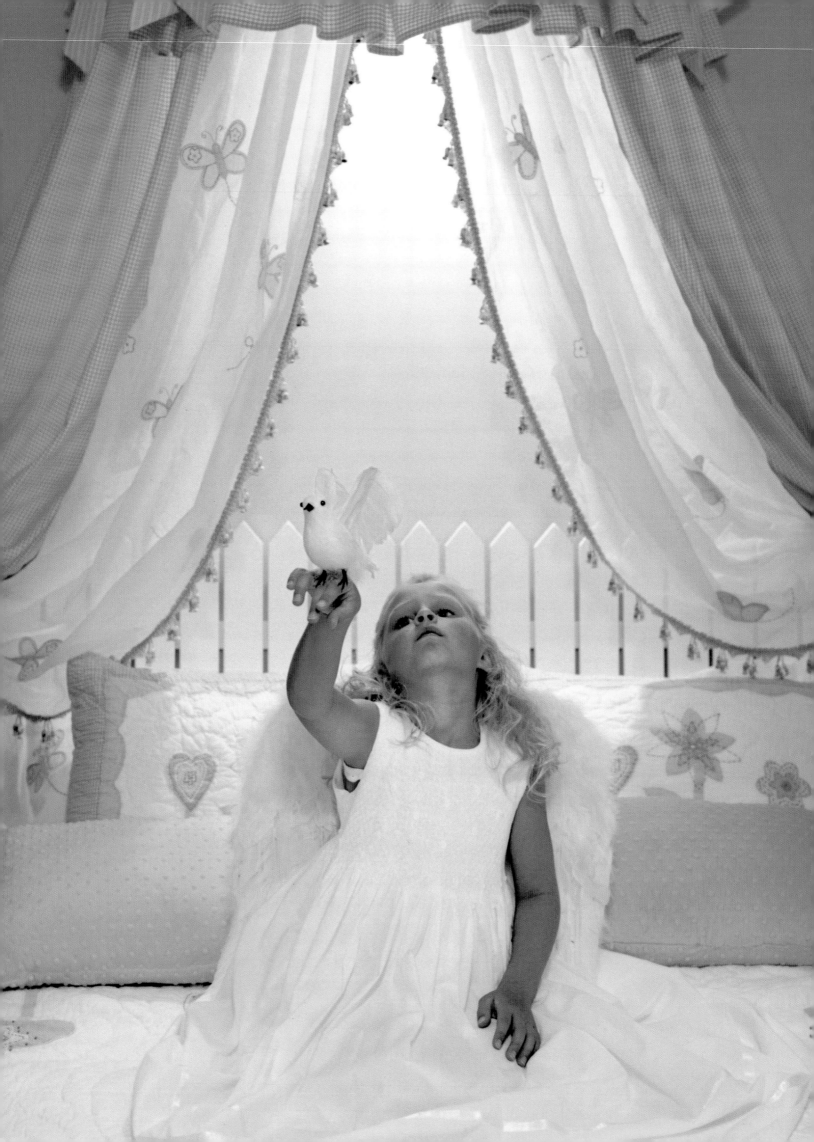

Preface

The National Museum of Women in the Arts is pleased to have organized *Role Models: Feminine Identity in Contemporary American Photography*, which takes an intergenerational look at thirty years of women artists acting up and acting out.

For more than two generations, photography has proved a perfect medium for provocative new approaches to and expressions of femininity as it relates to gender, sexuality, and race. In the first generation from 1975 to 1990, conceptual and appropriation artists Eleanor Antin, Cindy Sherman, Laurie Simmons, and Lorna Simpson used role-playing—borrowing iconic representations and stereotyped images from mass culture—as ironic signifiers and mediators of female identity. At the same time, other artists who came out of the documentary photographic tradition, such as Nan Goldin, Tina Barney, Mary Ellen Mark, and Sally Mann, eschewed the traditional objective detachment of the photo eye in favor of empathetic new narratives about female coming of age, while Carrie Mae Weems reformulated images and texts to create incisive commentaries on past and present social orders. Although these two types of photography were originally seen as antithetical, they were united in their desire to represent and/or critique women's changing roles in American culture.

In the second generation from 1990 to 2005, these two generative approaches to portraying "truths" about feminine identity were assimilated by younger photographers. As Katy Siegel wrote in her review of the 1999 exhibition *Another Girl, Another Planet*, these artists

> **understand and identify with the fragility and fierceness of girls, finding that as a social group they evoke certain states and feelings that persist in later life. The traits we associate with that awkward period between childhood and adulthood—hesitancy, ripeness, awkwardness, self-involvement, emotional intensity—seem to jibe more readily with conventional femininity than masculinity.**[1]

Using the strong aura of realism that photographic representation allows, these new skilled practitioners bridged the divide between conceptual and documentary photography. For Anna Gaskell, Katy Grannan, Justine Kurland, Nikki S. Lee, Sharon Lockhart, Catherine Opie, Barbara Probst, Collier Schorr, and Angela Strassheim, irony and social critique have given way to more ambiguous narrative styles, staged fantasies, and portraits. Role-playing now embodies both the exploration of familiar forms of femininity and the construction of new, more richly nuanced female identities.

In developing *Role Models*, I am first and foremost indebted to Heather and Tony Podesta. Their collection of contemporary photography by women, which I have seen grow dramatically over the past ten years, was the conceptual catalyst for the exhibition.

Angela Strassheim. *Untitled (Nicole with Bird)*, **2006.** (detail, Plate 71)

I also was fortunate to partner with talented individuals who were generous with their time, especially Dr. Michael I. Jacobs of New York, who has served as a special advisor to the project. Early on, Shelley Rice, Associate Professor, Tisch School of the Arts, New York University, lent her expertise to formulating and refining the exhibition's concept. I have been privileged to work with NMWA Curator of Modern and Contemporary Art Kathryn Wat, who brought fresh enthusiasm to the project when she joined the museum's staff in 2007. Our collaboration has been symbiotic, and I've appreciated her taking up the role of in-house counsel as well as co-curator for the exhibition. Invaluable help on the exhibition's catalogue and general organization also was provided by NMWA Research Assistant Catherine Roberts; and, as always, my appreciation goes out to Exhibitions Coordinator Rebecca Price, Exhibitions Registrar Catherine Bade, Chief Preparator Greg Angelone, and Preparator Quint Marshall for their unflagging devotion to and professionalism in realizing a curator's dream.

We are especially grateful for the privileged and substantial support that *Role Models* has received from individuals and groups inside the museum. At its inception, Lois Lehrman Grass, a member of the National Advisory Board and a true friend of contemporary art at NMWA, provided a generous planning and publication grant. We would also like to recognize the efforts of NAB member Margaret A. Race.

This was followed by major exhibition support from the museum's Business and Professional Women's Council through its *Enterprising Woman of Washington 2008* event that honored Gloria Story Dittus, President and CEO of FD Dittus Communications. Our warmest thanks to EWOW Chair Sharon Lee Stark, Corporate Giving Chair K. Shelly Porges, and BPWC Co-Chairs Arlene Fine Klepper and Sheila S. Shaffer, for their strong partnership with and dedication to sponsoring the *Role Models* exhibition and its educational programming at NMWA. We greatly appreciate the support of honoree Gloria Dittus and the following corporations and individuals: Booz Allen Hamilton, Citi Smith Barney, FTI Consulting, Inc. and FD, Alabama Power Company, Chevron, Rose Benté Lee Ostapenko, Shell, Southern Company, Visa, Inc., FD Dittus Communications, Time Warner Inc., Abbott, American Bankers Association, Diane Casey-Landry and Brock Landry, Clear Channel Communications, Harris Miller and Deborah Kahn, and Principal Financial Group. Generous support has also been provided by the National Endowment for the Arts.

We would like to further express our gratitude to the exhibition lenders and galleries whose contributions and assistance have made *Role Models* possible: 303 Gallery, New York; Brian T. Allen, Mary Stripp & R. Crosby Kemper Director, Addison Gallery of American Art, Phillips Academy, Andover, MA; Arnold Tunstall, Akron Art Museum, OH; Roberta M. Amon; Cass Bird; Collection of Melva Bucksbaum and Raymond Learsy; Deitch Projects, New York; The Collection of Francine Farr, Washington, D.C.; G Fine Art, Washington, D.C.; Gagosian Gallery, New York; Gladstone Gallery, New York; Greenberg Van Doren Gallery, New York; The Collection of Jack and Sandra Guthman; Michael Brand, Director, The J. Paul Getty Museum, Los Angeles; Jack Shainman Gallery, New York; The Collection of Dr. Michael I. Jacobs, New York; Janet Borden, Inc., New York; Shigeyuki Kihara; Lauren Greenfield Photography; The Collection of Scott J. Lorinsky, New York; Maier Museum of Art at Randolph College, Lynchburg, VA; Marian Goodman Gallery, New York; Mary Ellen Mark Library/Studio, New York; Marvelli Gallery, New York; Matthew Marks Gallery,

New York; Mitchell-Innes & Nash, New York; Montclair Art Museum, Montclair, New Jersey; Murray Guy Gallery, New York; Earl A. Powell III, Director, National Gallery of Art, Washington, D.C.; The Collections of Peter Norton and Eileen Harris Norton, Santa Monica; Rachel Papo; John Pelosi, The Estate of Diane Arbus; The Heather and Tony Podesta Collection, Washington, D.C.; Brian Ferriso, Director, Portland Art Museum, Oregon; The Project, New York; Regen Projects, Los Angeles; Collection of Lorenzo Rodriguez, New York; The Collection of Nicolas Rohatyn and Jeanne Greenberg Rohatyn, New York; Ronald Feldman Gallery, New York; Michelle Sank; Collection of Debra and Dennis Scholl, Miami Beach; The Collection of Steven Scott, Baltimore; Sikkema Jenkins & Co., New York; Elizabeth Broun, Margaret and Terry Stent Director, Smithsonian American Art Museum, Washington, D.C.; Sperone Westwater, New York; Lee Stalsworth; Stefan Stux Gallery, New York; Stuart Shave/Modern Art, London; Fran and Leonard Tessler; VII Photo Agency, New York; Adam Weinberg, Alice Pratt Brown Director, Whitney Museum of American Art, New York; and Yvon Lambert Gallery, New York.

The essays of two scholars enliven this publication in addition to the curators' essay. I wish to thank Shelley Rice, Associate Professor, Tisch School of the Arts, NYU, and Lucy Soutter, a writer and artist currently lecturing on photography at The London College of Communication, for their excellent contributions. For the publication of the beautifully designed and edited catalogue, I am indebted to Scala Publishers. It was our good fortune to work with such talented partners as Jennifer Wright Norman and Oliver Craske; project director Amy Pastan; copy editor Suzanne G. Fox; and designer Katy Homans.

Finally, our deepest respect and appreciation go to the artists whose provocations and pleasures we are privileged to share in *Role Models: Feminine Identity in Contemporary American Photography*.

SUSAN FISHER STERLING
Director

1. Katy Siegel, "Another Girl, Another Planet," Lawrence Rubin Greenberg Van Doren, NY, *Artforum* (September 1999): 161.

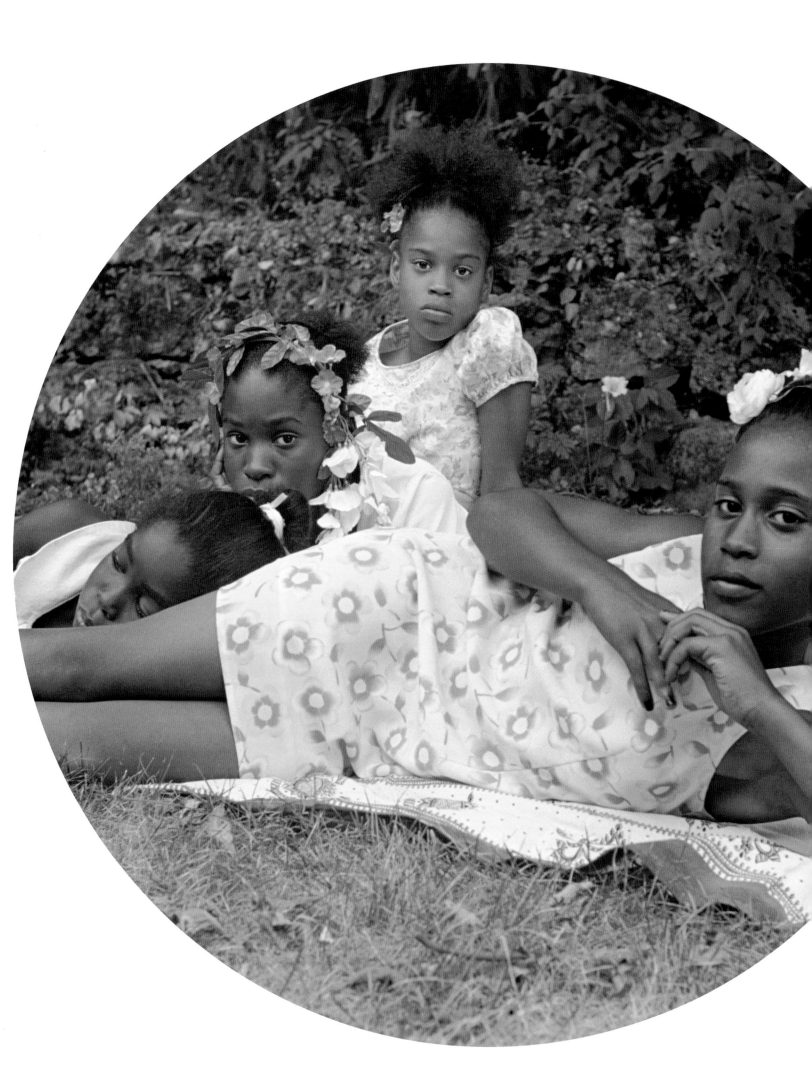

Enigmatic Spectacle: Key Strategies in Contemporary Staged Photography

LUCY SOUTTER

Role Models offers a valuable opportunity to take stock of the recent boom in staged photography and to ask why this way of working has been particularly fruitful for women artists over the past three decades. It also provides a moment to explore the pitfalls of staged imagery and to evaluate some of the criticism that has been leveled at the genre.

Staged photography includes many richly varied practices. These approaches have their roots in the histories of photography and contemporary art and are connected to notions of tableau and masquerade. Take, for example, Sharon Lockhart's taut cinematic action shots of Japanese school girls playing basketball from the *Goshogaoka* project of 1997 (Plates 55, 56); Nan Goldin's romantic, psychologically fraught *Self-portrait in kimono with Brian, NYC,* 1983 (Plate 5); and Anna Gaskell's *untitled #6 (wonder),* 1996 (Plate 40), showing a headless Alice lookalike jumping up and out of the photographic frame. These works have different visual properties, they refer to different cultural contexts, and they make meaning in different ways. But they also have areas of significant overlap. All three photographers work with the human figure and engage with subjectivity, particularly female. Their images all project a sense of deliberate self-consciousness and/or overt staging.

Like most contemporary artists, these three women create work in series, with the meaning of individual images relying on the totality of the project. Lockhart's *Goshogaoka* project was produced during a residency in suburban Japan, and involved collaboration with a professional choreographer who intensified the stylized movement of the girls' ordinary basketball drills. With a final form that included an hour-long 16mm film as well as still photographs, the project operates as a highly mannered social portrait. Goldin's work offers a totally different kind of portraiture, steeped in her individual sensibility made famous by the slide show and book versions of *The Ballad of Sexual Dependency.* Showing the artist with her lover Brian in front of an earlier portrait of him tacked up on the wall, the image describes the artist's experience as an endless loop of living, loving, and photographing. While Lockhart's work has an anthropological aspect and Goldin's has a diaristic feel, Gaskell's photograph plays on literary associations. Her closely cropped frame contains a parallel world, an imaginary space where psychological dramas are enacted.

Carrie Mae Weems. *After Manet,* from the series *May Days Long Forgotten,* 2003. (Plate 38)

Taken together, these artists span the key strategies in contemporary staged photography. Lockhart employs a crisp visual style, combining the skills of a documentarian and a cinematographer to create a heightened realism. Her process for developing work is highly conceptual, yet yields images of striking freshness. Goldin uses pose and lighting to relate to the emotional storylines and seductive appearance of Hollywood movies. Her images also refer to the vernacular aesthetic of family snapshots: in many, awkward cropping or a slight blur generate a feeling of authenticity. Of the three, Gaskell provides the most dramatic cues that the work is to be read as fictional. The deliberate artificiality of her close-cropped tableaux links her work to a history of staged image-making that includes academic painting as well as nineteenth-century pictorial photography.

The artists share an ambition for their work to be taken seriously as contemporary art. All are exquisitely attuned to the critical context for their practice, as well as to the subtleties of the different elements within each frame. And while all this work can generate critical discussion, it also is accessible to a wide range of viewers. Various series in *Role Models* are funny, poignant, beautiful, shocking, seductive, or fantastical. Most have a relationship to portraiture, the most familiar genre of photography. But in the hands of these artists, the portrait becomes a collaboration, a construction, or a provocation. Identity is at stake, and together these artists use staged photography to challenge all sorts of assumptions about what it means to be, see, or picture a woman.

From the beginning, staging has been used to address a fundamental tension in photography between the chaos of the visual world and the potential of the camera to order it into rectangles of sense. Two early images from the 1830s illustrate this problem. Louis-Jacques-Mandé Daguerre's famous early photograph of the Boulevard Voltaire is bewilderingly unstructured. It recedes in the familiar space of Western perspectival vision, but its ragged-edged composition and bird's-eye view are not determined by artistic rule, but by the camera's fixed position in the photographer's attic window. In the same period, Daguerre was making more conspicuous use of his artistic training with a handful of staged still-life daguerreotypes, including a small group of plaster casts clustered around a wine bottle to create a loose arrangement of rounded organic forms, the classic "bunch of grapes" composition recommended in treatises on rococo painting. The staging of these objects created an image that made sense not only as visual information, but also as a picture.

Photography's search for seriousness and aesthetic value has often involved borrowing ideas and vocabulary from painting. In the late nineteenth century, this overlap was complicated by the fact that painting itself was struggling between the rule-bound classicism of academic art and new influences; the harsh politicized realism of Gustave Courbet, the shockingly modern subject matter of Édouard Manet and Edgar Degas, and literary and occult threads in the work of the symbolists like Gustave Moreau. The clashes among classicism, realism, and symbolism carried over into early debates about photography as art and had direct bearing on the question of whether or not images could or should be staged.

In Britain, dueling photographic aesthetics were put forward in the pictorialism of

Henry Peach Robinson and the naturalism of Peter Henry Emerson. Robinson's book *Pictorial Effect in Photography* (1869) provided rules for making photographs into pictures, staged and posed rigidly around principles culled from British academic painting. Emerson's *Naturalistic Photography for Students of the Art* (1889) proposed that the key to artistic merit for photography was the study of nature rather than art. Emerson initially relied on a pseudo-scientific theory of differential focus to justify the distinctive atmospheric style of his images of disappearing rural ways of life. Despite their differences, Robinson and Emerson shared a desire to legitimate photography as an art form. Now, it is clear that both photographers used a degree of artifice in their work to create images that would function like paintings. A contemporary photographer like Jeff Wall would be much more likely to identify with Emerson's naturalistic approach, and with his interest in labor as subject matter. Yet Wall's use of digital manipulation and his reference to past works of art tie him back to Robinson's more academic orientation. The push and pull between a neutral observational aesthetic and conspicuous composing or montage carry right through to the work of many of the photographers in *Role Models*.

Towards the end of the nineteenth century, the movement advocating the acceptance of photography as art had taken root, with its own networks for discussion, exhibition, publicity, and distribution. The awkward classicism of Robinson had been replaced by a more subtle symbolist aesthetic. In the hands of internationally exhibiting practitioners like Alfred Stieglitz, F. Holland Day, and Robert Demachy, the term "pictorialism" had come to stand for ambitious photography that used veiled allegorical subject matter and an atmospheric visual style based on sensitive hand-working of prints to transcend the literalism of the photographic index. Making reference to painting, poetry, and music, these photographers staged their subjects to convey inner

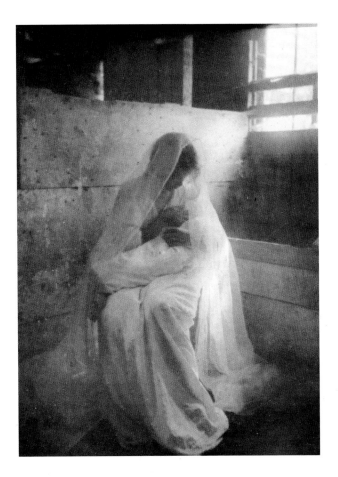

Figure 1.1
Gertrude Käsebier. *The Manger*, c. 1899, platinum print,
7⅞ x 5½ inches.

states and timeless truths rather than mere outer realities. This mode of photography particularly appealed to women, especially those affluent enough to acquire photographic equipment and chemicals. Photographers like Gertrude Käsebier used a pictorial style to celebrate female beauty and a feminine sensibility. Images like *The Manger*, c. 1899, in NMWA's collection (Fig. 1.1), were designed not only to echo paintings of the Madonna and Child but to convey a timeless sense of womanhood.

In the 1910s, pictorialism was eclipsed by a hard-edged modernist aesthetic and became synonymous with a kind of tired, backward-looking aestheticism, and even was linked to decadence. The modernist search for photographic essence led photographers like Paul Strand away from the soft shadows of the pictorialist platinum or gum print toward the sharp-contrast silver print. Metaphor, allusion, and symbol were replaced by the fragment, the close-up, and the crop, modernist devices of a radical new vision. In comparison with the purity of the new "straight" photography, the misty world of pictorialism was characterized, even vilified, as a feminized or effeminate realm. The story of pictorialism is a sidebar in the history of photography, the account of a loser in the modernist stakes for artistic credibility. The prejudice against a pictorial approach still lingers in the negative connotations of terms like "manipulated," "doctored," "distorted," or even "staged" when they are applied to photographic practices.

Yet this much maligned approach, which might be called "crooked" compared to the dominant narrative of straight photographic modernism, contains many important strands that have reappeared vigorously in contemporary staged work. Nan Goldin's expressive use of shadow, blur, and pose could be seen as relating to a pictorial tradition, making artistic use of the visual properties of the medium to create analogues for inner states. Anna Gaskell's references to *Alice in Wonderland* or Alfred Hitchcock's *Rebecca* could also be seen as a pictorialist turn, allowing photography to lean on literature or film, rather than asserting its modernist independence. In *After Manet*, 2003 (Plate 38), from *May Days Long Forgotten*, Carrie Mae Weems refers to a staple of pictorialist subject matter: artfully posed country girls with flowers in their hair. But while Henry Peach Robinson's pastoral idylls repressed class and gender issues in a sugary tide of nostalgia, *After Manet* confronts the viewer more squarely. At 34 inches across, the round c-print is larger than the intimate contact prints produced by nineteenth-century pictorialists. And in keeping with a broader project of retracing history and putting black female subjectivity back in the pictures, Weems has her central figure gaze straight out of the frame and into our eyes.

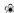

If many of the works in *Role Models* echo pictorialism, there are also many references to an opposing influence: documentary photography. In photography, the term "documentary" can refer to any image made as a record. It can refer more pointedly to images made with an investment in objectivity or truth. Social documentary sets out to right wrongs, generally by revealing the plight of the disadvantaged. Documentary strands have also run through the history of photography as art. Walker Evans understood documentary as a style, a rhetoric of objectivity. His photographic practice was grounded in his early study of French realist writers Gustave Flaubert and Honoré de Balzac. Despite its appearance of immediacy and truthful description, documentary

photography as it developed in the 1930s can be understood as a set of ways of telling stories about the world; it is not mimetic, but diegetic.[1] While Henri Cartier-Bresson and Dorothea Lange chose to convey their photographic messages in tight, iconic compositions, Evans opted for a rhetoric of frontality and plainness. The relative truth or beauty of such images is in the eye of the beholder; different approaches will appeal to different viewers. The acute self-consciousness of some of these early documentarians can be felt in the eloquent text written by Evans' collaborator James Agee in their classic book, *Let Us Now Praise Famous Men*. Several of the artists in *Role Models*, including Sharon Lockhart and Mary Ellen Mark, exhibit this kind of fascination with the real combined with rigorous self-awareness in approaching it.

If photographers in the 1930s and '40s were interested in a rhetoric of objectivity, in the 1960s, documentary took a subjective turn. Supported by photographic theorist and Museum of Modern Art curator John Szarkowski, street photographers like Lee Friedlander, Gary Winogrand, and Diane Arbus developed documentary as an explicit vehicle for personal expression, with the photographer's idiosyncratic vision more significant than the subject matter. Winogrand's imagery is a visual projection of his own libido, wit, and sense of irony. Friedlander broke all the rules of photographic composition, chopping up the picture plane with signposts, and making deliberate use of awkward edges and angles as well as his own shadow and reflection. Arbus drew out an intense vulnerability in her subjects, uniting disparate individuals into a kind of tribe in the way that she pictured them (Fig. 1.2). These subjective documents paved the way for a resurgence of staged photography. Many of the artists in *Role Models* deliberately blur documentary and formalism, realism and subjectivism. Nan Goldin, Tina Barney (Fig. 1.3), and Katy Grannan all work with the immediacy of documentary, but with a personal investment or interaction with their subjects, and an aesthetic that speaks of involvement rather than detachment.

Figure 1.2
Diane Arbus. ***A Family on Their Lawn One Sunday in Westchester, New York,*** **1968,** gelatin silver print, 15⅛ x 5 inches

15

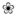

The influence of 1960s and '70s conceptual art appears as well in the work of most of the artists in *Role Models*. While the large-scale color images in this exhibition bear little resemblance to the scrappy black and white photos and accumulations of type-written text that characterized much of conceptual art, what they do share is a guiding logic or system—usually devised beforehand— to provide a conceptual framework for the images produced. Thus Katy Grannan's portraits, such as *Pleasant Valley, NY,* 2002 (Plate 44), are collaborations with sitters who have responded to classifed adver-tisements: "Artist/photographer (female) seeks people for portraits. No experience necessary. Leave msg."[2] This information is not included explicitly alongside the work, but circulates loosely around it in artist's statements, reviews, and catalogue essays.

As in much contemporary work, the concept is a supplemental narrative that operates as stealth content. Nikki S. Lee's *Projects* have a similar relationship to their guiding concept; the artist participates in subcultures ranging from pole-dancing (Plate 53) to hip-hop (Plate 54), resulting in images that are often shot by friends or bystanders. In handing over the camera, Lee is allowing the work to be influenced by chance and by social forces as well as her own performance. There would be visual interest to the work without access to the conceptual premise, but the work gets exponentially richer and more provocative when the viewer has access to the full range of ideas in play, such as the cultural dynamics involved when Korean-born twenty-something Lee infiltrated a group of Japanese schoolgirls.

First-generation conceptual artists were interested in photography as information, as a tool for conveying and structuring meaning. Narrative entered their work almost as a by-product. The ways they used serial photographs with text ended up generating a sense of sequence or duration that had rarely been seen in photography as art. At the same time, these works were often very austere visually, but full of anecdote, as the textual component of the work would allow a viewer or critic to reconstruct and describe the content of the piece as a biographical narrative of what the artist had done—release inert gas in the desert, follow a bird's song across a park, or pour bleach on a collector's carpet.

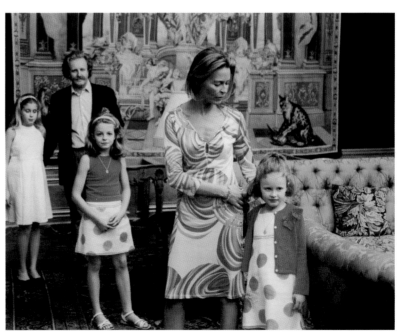

Figure 1.3

Tina Barney. *The Daughters*, from *The Europeans*, 2002, chromogenic print, 8 x 10 inches.

Eleanor Antin was unusual among conceptual artists in embracing narrative. As she describes it, narrative was a "dirty word" in an era of minimal and conceptual art.[3] Antin's *100 BOOTS* project was a joyful transgression of this taboo, a conceptual postal work that traced the cross-country journey of fifty pairs of black rubber boots as if they were the hero of a picaresque novel (Fig. 1.4). Antin sent the boots postcards out at erratic intervals between 1971 and 1973, deliberately including real time in the piece as well as the interval time scale of the narrative. When she went on to create *The Angel of Mercy*, 1977, a film-like sequence of images divined from the life of Florence Nightingale (Plates 10, 11; Fig. 3.2), or *Recollections of My Life with Diaghilev*, 1981, featuring "publicity photos" and texts about world-class ballerina Eleanora Antinova in her most famous roles (Plate 12), Antin embraced a different form of storytelling—the tableau—that harks back to the grand classical pictorial schemes of the seventeenth through nineteenth centuries. Although staged photography is often referred to as narrative, single images cannot unfold over time as do written or spoken narratives. Tableau is a time-honored format for condensing a range of subject matter into a single image, in which the importance of significant details and gestures compensates for the lack of unfolding. In his 1973 essay "Diderot, Brecht, Eisenstein," Roland Barthes discusses tableau as a self-conscious means for artists to present serious moral, social subjects in an intellectual way. For a text or image to function as a tableau, it must stand separate from the world and signal its constructedness:

> **The tableau (pictorial, theatrical, literary) is a pure cut-out segment with clearly defined edges, irreversible and incorruptible; everything that surrounds it is banished into nothingness, remains unnamed, while everything that it admits within its field is promoted into essence, into light, into view.[4]**

Barthes states that the self-consciousness of tableau makes it possible to channel the viewer/reader's emotion, and to generate ideal, metaphysical meaning, rather than imitative, anecdotal meaning. For photographers, one of the key aspects of tableau is that it is not about mimicking the world. It creates an artificial whole, a "pregnant moment" in which every gesture and detail becomes significant, even if it remains undecipherable. As Barthes observes, the actor's role in a tableau is not to be natural, but to embody excess, to signify the idea at stake.

Figure 1.4
Eleanor Antin. *100 BOOTS out of a Job, Terminal Island, California. February 15, 1972, 4:45 pm (mailed: September 18, 1972)*, 1972, gelatin silver print, 4½ x 7 inches.

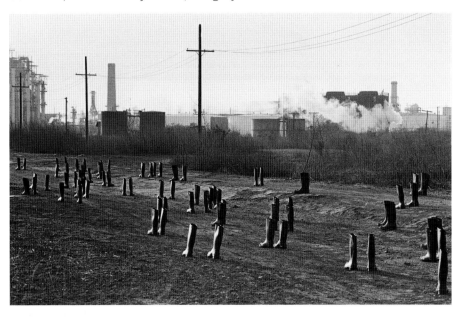

Although tableau needs to be fairly obvious for a viewer to recognize it, it must not be so far fetched as to alienate the audience. Barthes describes the way audiences long for narratives that are fresh (hence the "novel") yet comfortably familiar: "the 'author' is not the person who invents the finest stories but the person who best masters the code which is practiced equally by his listeners."[5] Herein lies the art for many of the artists in *Role Models*. To tell a new story that can be understood and enjoyed as such without its codes being seen—without its seams showing, so to speak—typically involves overlapping significantly with existing stories.

Cindy Sherman's *Untitled (Film Stills)*, 1977–80, also are very effective examples of tableaux. Their conventionalized form and built-in theatricality allows them to be perceived as being in a world separate from our own; and although they refer to codes of Hollywood B Movies, they do not allude to specific films. For many critics and art historians in the 1980s, this allowed Sherman's work to convey layers of critical subtext. In the *Film Stills* series followed by the Centerfolds of 1981 (Plate 1) and the Fashion series of 1983 (Plate 3), her work embodied key postmodern allegories about the end of artistic originality and the construction of identity, particularly female identity, by culture.

The notion of the postmodern constructed self, conditioned by media and lacking any authentic essence, was profoundly disempowering for many artists and viewers. But there was also something potentially freeing in the idea that a woman could present herself wearing a number of different masks, and that existing stereotypes might be unmasked along the way. Feminist film theorists describe this dynamic as "masquerade."[6] The notion of masquerade is potentially subversive and can be extended to encompass characters constructing their own sense of self by playing different roles, trying on different styles. The photographers in *Role Models* may borrow from the vernacular of movies, book illustrations, fashion, pornography, or any other genre. The self may be shifting and contingent, but the artist is figured as an active agent, constructing her own image. The masks can be actual personas, as in the work of Cindy Sherman and Nikki S. Lee, or they can be more subtle shifts in tone or point of view. Carrie Mae Weems combines text with images in various different ways, experimenting with different voices to critique existing representations and propose new roles.

Sally Mann occupied several different personas as she photographed her children. In a same way that an author might make use of narrators with different voices to explore a situation, Mann's gaze was sometimes tender and maternal, sometimes eroticized, sometimes even cruel. Many reviewers were up in arms about Mann's treatment of her children as subjects; it is very difficult for a photographer to convey the sense that a particular point of view in an image might be rhetorical rather than actual. This transgressive gaze is often difficult to take, particularly when the photographer is a woman and the subject a child. Catherine Opie, too, explores the different masks women may choose to wear, upending traditional expectations. In her *Self-Portrait/Nursing*, 2004 (Plate 60), we see the photographer naked from the waist up, cradling a baby in her tattooed arms. Her pose mirrors her earlier *Self-Portrait/Pervert*, 1994, which showed her hooded in leather, impaled with needles from shoulder to wrist, the word "Pervert" bloodily inscribed on her chest. Opie's work creates a new

rhetorical space for representing womanhood, pushing aside the existing limits of convention, law, and language.

Like a novelist or a playwright, the narrative photographer can explore real social issues in fictional form, and also give free rein to the unconscious. The work can express fantasies, transgressions, even impossibilities. In his classic study *Vision and Painting*, art historian Norman Bryson has argued that the tradition of Western painting has always been about cultivating desire through the gaze of the viewer.[7] He describes a figurative drawing or painting as a performance that erases itself. Realist conventions allow the viewer to ignore the traces of making and see the figure depicted as pure image. For Bryson, this is the great seduction of Western art, the way it draws the viewer in, arousing a scopic drive that is both pleasurable and sexual. In figurative photography, Bryson's "seductive illusion" is even more complete.

Collier Schorr's *Jens F.*, 1999–2002, published as a book in 2005, illustrates and thereby unmasks this effect (Plates 63–66). The piece is an extended portrait of a beautiful German schoolboy, Jens, whom Schorr first encountered on a train. Over several years, Schorr painstakingly photographed Jens in poses appropriated from a now well-known art historical source: Andrew Wyeth's private and obsessive study of his neighbor Helga, made over a fifteen-year period from 1971 to 1985. This source provides Jens with a full gamut of poses, from neutral to coquettish. Exhibited in a layered presentation with the Wyeth portraits, the images of Jens are awkward and seductive. They lay bare a curiously fraught relationship between artist and model, and unravel fixed ideas about gender, identity, and the gaze.

Not all staged work by women is necessarily pursuing a feminist agenda of empowerment or deconstructing social norms. Role-playing can just as easily preserve as subvert the norms of patriarchal society. Images like Justine Kurland's *Cyclone*, 2001 (Plate 47), could be read in very different ways. Some critics see Kurland's scenarios as feminist images of all-female spaces in which girls are free to act outside the male gaze. It would also be possible to read these images as male fantasies, spectacles of consumable femininity.

Almost a decade ago, I wrote an article titled "Dial 'P' for Panties" in response to a high-profile exhibition of staged photographs called *Another Girl, Another Planet*, and in particular to its sensationalistic subject matter of young women naked or in their underwear.[8] Looking at work by Anna Gaskell, Katy Grannan, Justine Kurland, and Malerie Marder, I set out to unpack the meaning of their pictures, which combined narrative, ambiguity, and nakedness. The essay provided an art historical context for the work, discussing it in relation to the subjective documentary photography of the 1960s, as well as the systematic structures of late-'60s conceptual art and the representational politics of '80s photographic postmodernism. I argued that this combination of influences was potent, but also potentially misleading. There was a tendency in art criticism in the 1990s to look for a critical element, a "critique of representation," in any ambitious contemporary art project. But were these images actually critical of anything? Some critics were reading them as feminist allegories, but to me, they seemed to overlap too much with unself-conscious commercial culture, with fashion, soft-core pornography, and advertising. I worried that in making such

seductive consumable fictions, the female photographers (mostly young and attractive themselves) were setting themselves up to be used and discarded by the art market like last season's clothes or accessories.

Time has proven me wrong. The photographers I discussed in the original article are all successful mid-career artists. We know from art history that edgy avant-gardes are inevitably absorbed by the system, and that yesterday's provocateur is tomorrow's academician. But it is not just that these photographers have grown up, that their projects have matured and become familiar. The market and audience for art photography has grown enormously in the past few years. Staged photography has become one of the key areas of practice. The way we understand constructed narrative work has changed, in part as the projects of these photographers have evolved and become more complex. More often than not, the constructed photograph is guided by a pre-determined conceptual premise or is based on something the artist/photographer has seen firsthand. The relationship between the photographer and model may take many different forms, creating hybrids of fiction and document. The photographers in this exhibition have been pioneers in this area of photographic practice and they have become role models for younger photographers.

My original emphasis on underpants was slightly unfair—sex was only part of the story—but it was not completely off target. Desire lies at the heart of this work. In re-examining Gaskell, Grannan, and Kurland, alongside the other photographers in *Role Models*, I would like to give them more credit for the complex ways they mobilize desire. The border between staged and documentary work continues to fascinate because it offers a space to explore real-life attitudes, subject positions, and relationships with limited real-life consequences. It is not a coincidence that so many narrative photographers are women; staging provides an ideal opportunity to explore gender roles and power relationships.

Ten years ago, I had difficulty seeing pictures of girls in their underpants as a feminist enterprise. I was resistant to the concept of "subjectification," in which the female figure is not objectified if she occupies a position of confidence and control.[9] As promoted by the Spice Girls, "Girl Power" seemed more cynical marketing ploy than reality. Over time, I have come to see these artists as representatives of an evolving contemporary feminism: one in which women are cultural and sexual creators free to occupy a variety of subject positions. Like most generations of women, these artists rebel against the feminists before them. Visual pleasure, ambiguous narrative, and a transgressive relationship to documentary truth have been hallmarks of their rebellion.

The staged images in *Role Models* are both private and public; for the most part, they depict small-scale events of everyday life, writ large and laden with significance. These are gallery pictures, museum pictures, claiming seriousness for themselves and their makers. But despite their public address, there is also something mysterious about these pictures, something held back that cannot quite be described or accounted for. Staged photographs are trapped in time; they can never quite unfold into full narratives, and remain forever unresolved. Roland Barthes argues compellingly that narrative is not mimetic at its core. As he puts it, "The function of narrative is not to 'represent,' it is to constitute a spectacle still very enigmatic for us. . . ."[10] The passion that drives artists to make and viewers to view staged photographs is not purely intellectual, it is also about emotion: the hopes, fears, and urges that lie at the heart of life as well as art.

1. Jean-François Chevrier, "The Tableau and the Document of Experience," in *Click Double Click: The Documentary Factor* (Munich: Haus der Kunst and Brussels: Center for Fine Art, 2006), 51–61.

2. Jan Avgikos, *Katy Grannan: Model American* (New York: Aperture, 2005).

3. Eleanor Antin, interview with Howard N. Fox in *Eleanor Antin* (Los Angeles: Los Angeles County Museum of Art, 1999), 204.

4. Roland Barthes, "Diderot, Brecht, Eisenstein," in *Image-Music-Text,* Stephen Heath, trans. (New York: Noonday Press, 1977), 70.

5. Barthes, "The Structural Analysis of Narrative," in *Image-Music-Text,* 114.

6. Mary Ann Doane, "Film and the Masquerade: Theorizing the Female Spectator," in *Femmes Fatales: Feminism, Film Theory, Psychoanalysis* (New York and London: Routledge, 1991), 17–32.

7. See Norman Bryson, *Vision and Painting: The Logic of the Gaze* (New Haven: Yale University Press, 1983).

8. Lucy Soutter, "Dial 'P' for Panties: Narrative Photography in the 1990s," *Afterimage* 27 (January/February 2000): 9–12. *Another Girl, Another Planet* was curated by Gregory Crewdson and Jeanne Greenberg Rohatyn at Greenberg Van Doren Fine Art in New York City in spring 1999.

9. For an account of crosscurrents in twenty-first-century feminism, see Jennifer Baumgardner and Amy Richards, *Manifesta: Young Women, Feminism and the Future* (New York: Farrar, Straus, and Giroux, 2000).

10. Barthes, "The Structural Analysis of Narrative," 123–24.

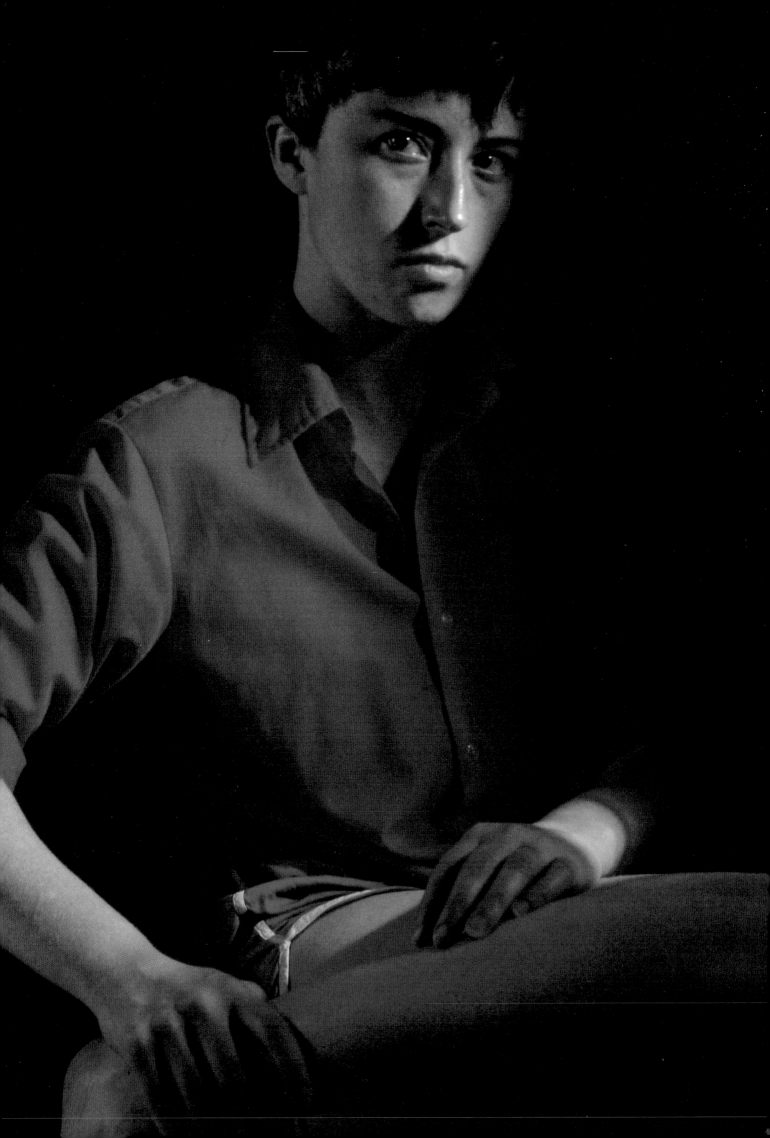

Crosscurrents: Models, Migrations, and Modernisms

SHELLEY RICE

The exhibition *Role Models* begins with an opposition, the two modalities of creative photography that defined the medium in the 1970s. On the one hand, we have Nan Goldin, the documentary photographer who began "performing" her slide show, *The Ballad of Sexual Dependency*, in the night spots of New York's Downtown scene late in the decade. Nan's startlingly intimate photographs of her friends—drug addicts, battered women, AIDS patients, punks, and homosexuals, among others—updated Diane Arbus' peep show into the lives of the down, desolate, and desperate by proclaiming the personal involvement of their author. These exiles from the mores of Middle America were Goldin's "constructed" family; her snapshots allowed her not to be a "supertourist"[1] in other peoples' realities, as Arbus was in the land of the little people and the transvestites, but to expose from inside the lives and loves, and the ties that bind young people living on the margins of the urban landscape.

There are many assumptions behind such a body of work, many attitudes that need to be deconstructed to understand the messages we receive from Goldin's images. Over the years, her work has evolved as a narrative, with each photo functioning as a freeze frame in an ongoing film. Nan and her friends love and lose, live and die; they move, together and separately, through time and space, and the artist, voyeur as well as participant, reacts to the changing surroundings and situations. Her involvement in these difficult, often tragic, scenarios is what holds us all in Goldin's thrall. We know that she, like the battered women and addicts she depicts, cannot extricate herself from the web of doom within which she is caught, no matter how clearly she describes and analyzes her pain. The inevitability of this destiny is implied in every picture Goldin takes; when she sends us postcards from the edge, she allows us to feel the downward spiral, and thus to expand and generalize our own emotional experience of the human condition. The subjective, the invisible, have all been made visible in this body of work. Through the magic of empathy (and the art world's global distribution network), a private experience, once fixed by the camera, has moved into the public domain.

This "public domain" is very important to this discussion, since the relationship between public and private, between the external world and internal perception, is in fact what separates Nan Goldin's work from Cindy Sherman's. Goldin is older than Sherman, and her embrace of the impassioned intimacy of humanistic straight photography marks her as someone coming out of naturalist photographic traditions

Cindy Sherman. *Untitled #112*, 1982. (detail, Plate 2)

begun in the late nineteenth century. The idea that a photograph can capture the subjective vision of the artist, can conflate human emotion with a visual image of the physical world, was first proposed by P.H. Emerson in the 1880s, and was for 100 years the reigning premise of Western art photography. That is, until the generation of Cindy Sherman, coming not from the photo field but from the art schools, began to redefine the way we look at—and relate to—pictures. For Sherman and her post-modern compatriots, weaned on television and conceptual art, photographs did not *embody* the inner life of the artist—they *shaped* it. Sherman's work begins not with the subjective responses of the artist/monad but with the shared cultural images, already in the public domain, that shape her/his sense of identity and the world. Her confla-tion of inner archetypes with outer media identifies the self not with personal expres-sion, but with the collective icons that she, as a woman and an artist, appropriates as her own, and describes not within the time and space of her life experience, but in "constructed" theatrical tableaux. Such an attitude toward pictures was shocking in the early 1980s, but its impact on both the art world and photography has been immense—as *Role Models*, of course, makes clear.

But there is no clear evolutionary tale being told in this exhibition, no fairy tale about how the modernists were defeated by their avant-garde cousins. The relation-ship between documentary photography and directorial photography, the diverse ways in which the two describe identity and the self in photographic portraiture, weave a complex web of codependency. To fully understand the larger influences upon the second generation of American photographers, we need to cast our net wider than the borders of the United States, and move into the global image world to study the ways in which our new, international interconnectedness has inflected the models women use to shape both their art and their life.

Figure 2.1

Rineke Dijkstra. *Almerisa, March 14, 1994,* 1994,

chromogenic print, 50½ x 43 inches.

Although her work is outside the purview of this exhibition, probably the earliest and most extraordinary example of the convergence of Goldin's documentary style with Sherman's postmodern ideas about constructed identity is a series of portraits by the Dutch artist Rineke Dijkstra. Beginning in 1994 and continuing almost annually for eleven years, Dijkstra photographed Almerisa, a young Bosnian refugee in Holland. Having arrived in a strange country as a small child, neatly dressed in the clothing of her homeland, Almerisa's passage through time shows a child growing into an adolescent, and finally a young woman (Figs. 2.1, 2.2). But this is a child of migration, one of many whose fortunes have been affected by war and whose personal growth becomes synonymous with adaptation to changing social, geographic, and political circumstances. As she grows from a shy child in a plaid skirt to a self-assured teenager in jeans and tee shirt, she manifests not only biological growth but also cultural assimilation, visible especially in the evolving "uniforms" that increasingly proclaim her identification with the dress, hair styles, and body language of her Dutch peers. These are straight photographs, large-scale color portraits that embed Almerisa in specific times and spaces and connect Dijkstra to photographic traditions central to the medium's history since the 1840s. But the meaning of the Bosnian Girl series places it squarely in Sherman's postmodern corner: taking as her starting point the fact that all of us forge our self-images within the context of expanding spatial parameters, Dijkstra shows us the process by which we construct and project our social identities in accordance with the visual cues in our diverse and multiple local environments.

This is art made in a global world, in other words, where local traditions and visual signs begin to give way to the international language of travel, tourism, the internet, migrations (whether forced or freely chosen), outsourcing, and transnational corporations. All of us cross borders, breach boundaries, and know that when we do so,

Figure 2.2
Rineke Dijkstra. *Almerisa, Liedschendam, The Netherlands, June 25, 2003*, 2003, chromogenic print, 50½ x 43 inches.

we will be judged not by our intrinsic character, but by our clothing, our body language, and our hair style: those trivial markers that are the stuff of Chick Lit when we stay in the 'hood with our childhood friends and observe the local customs. Globalization has changed all that. Not only do we now spend much of our lives in the presence of strangers who know little about our backgrounds and less about our inner lives, but we also need to provide these passersby with basic information about our origins—or at least the parts of our origins we want them to see. Identity becomes a fluid projection under these circumstances: a personal fiction "performed" in public and changed at will, so all need to know the ground rules of the masquerade. Participation in a global society, in other words, demands that we understand the relativity of fashion, to grasp and manipulate not only its aesthetic diversity, but also its political, and especially its symbolic, implications. Visual clues no longer provide purely documentary information; specific choices of body language and hairstyle function as conceptual flags, signaling more general collective concerns.

We are moving away from the humanistic idea that "character" is an internal state, essential to the monad and visible from the inside out. Now identity is selected by the individual, in response to outside signs and pressures, as a mode of communication. Visual choices can signify a whole range of social positions: not only class, ethnicity, and gender, but also conformity, resistance, acquiescence, outreach, and challenge. In short: on Facebook, in youth hostels, conference halls, and international airports, we are all Cindy Shermans.

This must change our way of looking at contemporary art: rather than simply being an avant-garde style with market potential in a gallery, it does indeed reflect a new concept of identity construction that has currency among both artists and their audiences worldwide. Once again, a comparison of work by two artists in *Role Models* can help to clarify the relevance of this visual shift. Representing the older generation of American women, Mary Ellen Mark, in series about runaway kids in Seattle (Plates 30–33) or prostitutes on Falkland Road in Bombay, shows us the efficacy of "concerned photography": its ability to bring back, from the far flung corners of the world if necessary, stories about those who suffer, who need the help of privileged people (like American viewers). Concerned photography is, above all, activist photography. Mary Ellen, the mobile eye, travels the globe and brings back postcards, describing the lives, geographic and social spaces, costumes, and mundane activities of Others trapped in their local spaces and difficult lives. We too stay home, and empathize (through magazines, or museum shows) with the plight of those less fortunate. Working off the "depth" model described by Fredric Jameson,[2] the *raison d'être* of her photographs is to present us with subjects, situations, and emotions that resonate with, and communicate, a profound, and shared, human condition.

It should be noted that the "activist" in this equation is the photographer: she is the one who moves between worlds and transmits information, who functions as the "supertourist" Susan Sontag described. This idea of the roving photographer, so fundamental to the heyday of picture magazines like *LIFE* and *Look*, seems outmoded by contemporary standards, when everybody is on the move all the time. The foil to Mary Ellen Mark is Nikki S. Lee, the young Korean photographer who arrived in New York for college during the 1990s and stayed. Nikki's graduate thesis project at New York University made her famous. A series of "snapshots" of the artist dressed

in the garb of various American subcultures, hanging out with Puerto Ricans (Plate 51) and skateboarders, yuppies and exotic dancers (Plate 53), the elderly and the Middle Americans (Plate 52), they exhibited not only her photographic prowess but also her remarkable ability to blend in anywhere, with anyone.

Whereas Mark uses her "outsider" status as a guarantee of objective reporting in the diverse situations within which she works, Nikki Lee makes art *about* being an outsider. Looking at the diverse subcultures of her adopted homeland, Lee coveted entry into their mysterious worlds. She realized that her understanding of collectivity in Asia—where social identity is defined by the group and not by the individual—would help her relate to various communities in the U.S.A. "I take the snapshot format of the West, which represents individual memory and identity, and use it to describe the group identities I know from the East," she told me.[3] Her version of multiculturalism is completely performative. Lee spends months studying the group she wishes to penetrate. She observes their rituals and codes, their shared body language and tastes; she shops for appropriate fashions, gains or loses weight, and learns requisite skills like pole or swing dancing. By the time Nikki approaches her subjects and asks to be photographed among them, she has merged so completely with their style that even her Asian face does not mark her as a foreigner. Accepted by her new acquaintances even though she tells them she is an artist doing a project, Lee takes pictures that feign a completely credible intimacy. As an outsider, she knows that no one is foreign to her, and that we are all strangers in our strange land, which is far from homogenous. Whereas Mary Ellen Mark wants us to empathize with the humanity of everyone, Nikki Lee knows she can *be* anyone—through careful observation, and smart shopping.

On a certain level, Lee's work gives the lie to many of our assumptions: about intimacy and memory, about individuality and psychology, about the seamless relationship between internal states and external appearance. Surely the mother of such critiques is the French artist Orlan, best known for the series of plastic surgery operations she underwent in the early 1990s, transforming her face into those of various saints and sitters from art history. These operations, however notorious, fit in with a more than thirty-year career of performance art, photography, media, and installation work examining the possibilities of what Lucy Lippard termed "transformation" art.[4] Orlan's physical mutation of her "real" face has always shocked Western audiences, who persist in seeing such an invasive action as damaging to the individual's psychological health. The artist's protestations to the contrary, her consistent assertion that her body is her canvas and has absolutely nothing to do with her psychology or internal life seemed, until recently, like madness. But work like Nikki Lee's gives new credence to Orlan's statements.

At the moment, Orlan is working with art about multiculturalism: she told me that ideally she would like to put skin cultures from four or five different races in a Petri dish and "grow" it.[5] The visual face of this project in galleries and museums has been a series of large-scale photographs in which the artist transforms her own face (through Photoshop this time) into a *hybrid* of different races and cultural styles (Fig. 2.3). Ethnographic pastiches are not new to the arts, of course: Picasso's *Demoiselles d'Avignon* in 1907 was followed by the significant photomontages by the Dadaist Hannah Höch during the 1920s. Entitled *Ethnographic Museum*, this extraordinary series used the cut-and-paste method to merge racial and cultural characteristics of

women, and thus to proclaim the fractured wholeness of us all. Höch was a European bisexual, but in the postcolonial world of contemporary art, it is often people of ethnic backgrounds who manipulate and proclaim the multiplicity of their identities. Claiming a voice in the art world dialogue that until now was only open to white men, they use both traditional and modern costumes and accessories to make statements about their past, their present, and their possible futures.

Fiona Foley of Australia, for instance, is an Aboriginal descendent of the Badtjala tribe, based on Thoorgine (Fraser Island); like Shigeyuki Kihara of Samoa (Fig. 2.4), she uses her own body, and those of her friends, to reclaim the heritage and memories lost during the years of colonialism by donning traditional dress and "re-enacting" racial roots. (Foley feels enough kinship to the Seminole tribe of Native Americans in Florida, who also lost their lands to white settlers, to photograph herself in their historic garb as well, in solidarity. Orlan is certainly not the only one to think across racial lines.) Other artists, like Tracey Rose of South Africa, use their self-portraits to challenge the injustices of their colonial histories. Dressed up like Saartje Baartman, the South African caged and toured throughout Europe during the early 1800s as a "freak" of nature because of her copious physique, Rose defiantly claims "the Hottentot Venus'" shame and sexuality as her own (Fig. 2.5). Brazilian artist Janaína Tschäpe makes photographs and videos that amplify the mythology of Iemanja, the Goddess of the Sea, and explore her capacity to embody the ancestral concept of feminine power (Fig. 2.6).[6] During the 1990s, Tschäpe worked within the *favelas* (slums) of Brazil, helping poor women reclaim their spiritual strength by choosing and then "performing" images of authority and fortitude.

Artistic expression involving masquerade is often seen as a uniquely feminine

Figure 2.3

Orlan. *Reconfiguration/Self-Hybridization Pre-Columbian °27*, 1998, Cibachrome print, 63½ x 42½ inches.

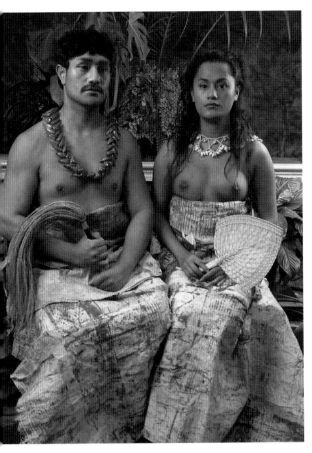

Figure 2.4

Shigeyuki Kihara. *Ugali'i Samoa: Samoan Couple,* **from the series entitled** *Fa'a fafine; In a Manner of a Woman,* **2004–2005,** chromogenic print, 31½ x 23⅝ inches.

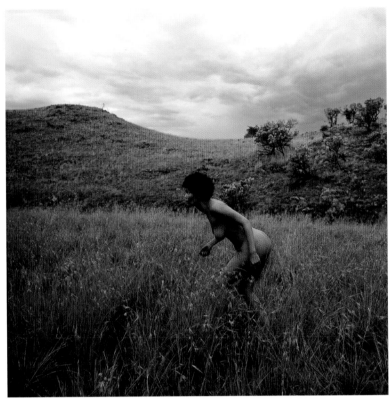

Figure 2.5

Tracey Rose. *Venus Baartman,* **2001,** lambda print, 47 x 47 inches.

Figure 2.6

Janaína Tschäpe. *Livia 2,* **2003,** Cibachrome print, 40 x 50 inches.

form of expression, but it is not—that is, in fact, only stereotypical thinking. The same tools, and postures, are being used to great effect by men all over the world, especially those who, like Kihara and Foley, feel that they need to claim a place in the global dialogue dominated by white men. Probably the best known is the Japanese artist Morimura, whose series *The Daughter of Art History* is literally his attempt to put himself in the picture. Dressing up like sitters in famous works by Manet, Goya, or even Cindy Sherman, he visualizes the dilemma of artists who are left out of the dominant Western aesthetic tradition because of their race and cultural background. Often cross-dressing to make his points, Morimura places himself in good company. Samuel Fosso from Cameroon visually signals his participation in contemporaneity by donning the costume of a liberated American woman of the 1970s (Fig. 2.7). And African American Lyle Ashton Harris has made devastating self-portraits dressed as goddesses of both African-based religions and African American culture, like Billie Holiday.

Cross-dressing, however, is not simply a sexual transformation in the art world. One of the major themes of recent imagery is the way in which globalization makes demands on all of us that stretch not only our understanding of gender but also of political and religious allegiance. Lauren Greenfield (Fig. 3.1) and Sally Mann have both done substantial bodies of work about the "formation" of American girl culture in adolescence, but young artists faced with migrations, wars, and social upheavals are working with different problems of acculturation. Rachel Papo, a young Israeli artist, has documented the visual manifestations of army culture—the boots, uniforms, guns, bars, and body language—transforming young women serving in her country's military (Fig. 2.8). This version of cross-dressing plays with our stereotypical ideas of gender roles, but the young Papo's matter-of-fact records of army life are a far cry from the horror expressed by the older artist Shirin Neshat in the 1980s. After the Iranian Revolution that left her permanently in exile, Neshat created a series of black and white photographs of women in traditional Islamic dress, their bodies covered with

Figure 2.7
Samuel Fosso. *La femme Americaine liberée*, 1997,
chromogenic print, 20 x 20 inches.

calligraphy transcribing feminist Persian poetry, flanked incongruously by both guns and children. Another younger Iranian woman, Marjane Satrapi, grew up in Tehran in the wake of the revolution and was sent away to Europe by her parents as a young teenager. She has described the split value systems of Muslims trying to adapt to life in the West in two autobiographical graphic novels (recently made into a full-length feature film) titled *Persepolis* and *Persepolis 2*.

These contradictory yet coexisting value systems are, of course, at the root of our new global identities, and they shake up not only our notions of local space but also millennium-old ideas of local time and tradition. Mobility and international travel call into question everything we know and build walls between the perceptual patterns of

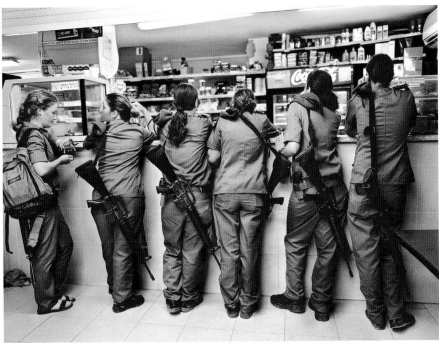

Figure 2.8
Rachel Papo. *Serial No. 3817131 #2, Soldiers waiting for service at a military kiosk counter. Shaare Avraham, Israel*, 2004, chromogenic print, 30 x 40 inches.

Figure 2.9
Mariko Mori. *Tea Ceremony III*, 1994, chromogenic print, smoked aluminum, and wood, 48 x 60 x 2 inches.

the generations. Children growing up in traditional families in the new skyscrapers of Taipei, for instance, like those depicted in the Taiwanese film *Yi Yi*, cannot abide by (or even understand) the Old World values of their revered grandparents. Visualizing the same schism between the international world of her experience and the traditional world of her upbringing, a Japanese artist like Mariko Mori creates photographic tableaux like *Tea Ceremony III*, which can merge the two (Fig. 2.9). Standing on a street corner surrounded by businessmen rushing around in suits, she enacts the age-old role of the little woman who subserviently offers men a cup of tea. Lin Tianmiao, in her *Self Portrait* of 2001, embodied this dissonance by intertwining classic Chinese braiding with new media like digital photography and video. The incongruity of the temporal and social clash characteristic of the new globalization is also the subject of Annu Palakunnathu Matthew's *Virtual Immigrant* series. Visualizing Thomas Friedman's "Flat World,"[7] which has deeply affected the lives of those in her homeland India, she makes portraits of people shuttling between their native dress and the modern business clothes they must wear to their outsourced Western jobs at local call centers. Mobility, a series like this seems to say, no longer requires a road trip. Some of us traverse borders, economic classes, and cultures regularly, if not seamlessly, just staying home.

But others still crave the open road. Consider several young lesbian artists who've made spatial mobility, especially across the United States, the subject of their works. Interestingly enough, two of the women mentioned here are rock stars, and the borders they cross are not only spatial but cultural: they move effortlessly between mass popular culture and the elite precincts of the avant-garde art world. J.D. Samson, a member of the rock band Le Tigre, has done a whole series of photographs (with Cass Bird), titled *Lesbian Utopia*. Published as a calendar in 2006 and shown simultaneously at Deitch Gallery in New York City, the series chronicles her travels in an RV with a group of women and her recreational stops at gay campgrounds across the country (Fig. 2.10). Appropriating and embodying the masculine image of freedom

Figure 2.10

Cass Bird, *Chicken Fight*, from the *JD's Lesbian Utopia* series, 2005, chromogenic print, 20 x 24 inches.

made famous by Jack Kerouac in his novel *On the Road* in the 1950s, Samson also used the calendar format to transform herself into a postmodern, cross-gendered pin-up. Her friend Wynne Greenwood, sometimes performing as Tracy and the Plastics, uses the road trip as a central metaphor in many of her pieces.

Traveling for her music career, playing concerts for audiences in strange places over extended periods, she has become highly sensitized to the differences between personal and impersonal encounters, in private and public spaces. Both the 2005 performance *ROOM* and the video *New Report* (a hilarious faux news broadcast with feminist flair, produced in collaboration with K8 Hardy) explore the implications of these aspects of contemporary experience. Works by these artists often help us to understand the old adage that "home is where the heart is"—but their new home is speeding along on the highway, and their hearts are reaching out to friends all over the globe. These young women, in other words, are a far cry from Nan Goldin's sitters, trapped in their destinies and their lives. The road trip keeps moving the younger generation forward, expanding their horizons, allowing them to experience situations inconceivable to earlier generations of American women. We shall see—they will surely tell us—where all these inter- and intranational crosscurrents ultimately lead.

1. Susan Sontag, *On Photography* (New York: Farrar, Straus, and Giroux, 1977), 42.
2. Fredric Jameson, "The Cultural Logic of Late Capitalism" in *Postmodernism, or the Cultural Logic of Late Capitalism* (Durham: Duke University Press, 1992), 8–9.
3. Nikki S. Lee in conversation with the author and her students at New York University, New York City, 2001.
4. Lucy Lippard, "Making Up . . ." in *The Pink Glass Swan: Selected Essays on Feminist Art* (New York: The New Press, 1995), 89–98.
5. Orlan in conversation with the author, Paris, 2004.
6. Tschäpe's earliest video of Iemanja was first shown in the U.S. at the National Museum of Women in the Arts in the 2001 exhibition *Virgin Territory: Women, Gender, and History in Contemporary Brazilian Art*.
7. Thomas L. Friedman, *The World is Flat* (New York: Farrar, Straus, and Giroux), 2005.

Fashioning Feminine Identity in Contemporary American Photography

SUSAN FISHER STERLING AND KATHRYN A. WAT

In our image-conscious world, photography is one of the most powerful mediators of our sense of self. Whether we are looking inward to try to understand and establish who we are or outward to see who we might wish to be, it is a truism of contemporary life that we view ourselves through the camera's eye.

Exploring the ways in which female identity is constructed and mediated through the art of photography is the central theme of *Role Models: Feminine Identity in Contemporary American Photography*. It features the work of two generations of artists—eighteen in all—whose portraiture, self-portraiture, and narrative photographs have indelibly inflected our understanding of gender and identity over the past thirty years. More specifically, the exhibition focuses on how role models and role-playing have been central to the art, meaning, and social function of contemporary photography.

THE FIRST GENERATION

In the 1980s, American photography experienced a remarkable sea change as women such as postmodern artist Cindy Sherman and documentary photographer Nan Goldin re-envisioned how identity and gender could be defined by the camera. In her *Untitled Film Stills* of 1977–80, Centerfolds of 1981, and Fashion series of 1983, Sherman simulated feminine roles as expressed through magazines, television, and film (Plates 1, 3). She worked in a performative mode, serving as her own model and using makeup and props to develop a number of identities. Her photographs illuminate the pervasiveness and persistent appeal of conventional models of femininity such as the ingénue or the vamp.

Goldin was intent on the close documentation of her own life's story. Her photographs of friends, lovers, and herself in the intimate spaces of their homes and hang-outs are gritty and unsparing (Plates 5–9). The scale and scope of *The Ballad of Sexual Dependency*, 1981–96, outstrips the ambitious photo-documentation projects of the 1940s and '50s. But Goldin's images are so relentlessly personal that they have both a decadence and allure that confounds their journalistic premise. Sherman's and Goldin's photographs established a new and much larger arena for women's self-representation in contemporary photography. As complementary approaches, their work stands at the center of *Role Models*.

Sherman and Goldin were not alone, of course, in their interest in drawing attention to the external social codes as well as the internal subjective drives that framed

Nan Goldin. *Cookie in the NY inferno, NYC*, 1985.
(detail, Plate 6)

35

gender and identity for their generation. In the 1980s, many women artists and photographers realized that they could be both the creator and the subject of their work. Liberated by the feminist and civil rights movements of the 1970s, these women developed a place for their work within the big picture of identity construction in American society. The first-generation photographers in *Role Models* avidly explored how gender and identity, including lesbian and transgender lifestyles, could reflect the changing social order of the 1980s.

Some of the artists in the exhibition from this period, such as Sherman and fellow postmodernists Eleanor Antin, Laurie Simmons, and Lorna Simpson, developed photographic approaches that revealed and critiqued stereotypical notions of femininity, sexuality and, in Simpson's case, race. Like Sherman, they took on roles and acted out a feminine masquerade for the camera, using staged set-ups, stand-ins, and synecdoche. In doing so, they expressed the fragmented nature of contemporary feminine identity. They also recast photography as an appropriate medium for allegory and metaphor, with a healthy dose of irony thrown in.

These postmodern works were radical and distinctive from traditional documentary photography, which aimed to record the "truth," or capture a decisive moment from a distance. During the 1980s, documentary photography also was being recalibrated from the inside by women such as Nan Goldin, Tina Barney, Sally Mann, Mary Ellen Mark, and, in her early career, Carrie Mae Weems. These women drew upon the special bond of kinship or friendship to create photographs of and about children, families, acquaintances, and/or themselves. In doing this, they regularly depicted the varied roles that girls and young women "tried on" as part of the internal, subjective struggle to find a gendered identity that fit. While other documentary photographers questioned their methods of engagement, the public saw their images as compelling social commentary.

Susan Sontag pointed out that Nadar was famed for both his glamorous portraits of celebrities and topographical landscapes that showed a new view of the natural world. His oeuvre encapsulated photography's twin capacities to subjectivize reality and objectify it.[1] The first-generation artists in *Role Models* amplified photography's ability to weave a story and express truth, often simultaneously. Cindy Sherman's photographs caused a sensation because viewers delighted in the appropriated fantasies

Figure 3.1

Lauren Greenfield. *Kristine, 20, poses for a lingerie shoot for* Ocean Drive Magazine *in Miami Beach, Florida. In contemporary American culture, beauty is a marketable commodity for some girls*, 2002,

Cibachrome print, 20 x 30 inches.

she created and the effort she made to assume so many different characters. Yet viewers were also moved by a truth they perceived in her images about women's experiences in contemporary culture. In the 2002 series *Girl Culture*, documentarian Lauren Greenfield (Fig. 3.1) describes her work in a similar way:

The process of making these photographs was . . . less narrative and intellectual than my usual journalistic approach—which somehow made it feel truer, as though it was coming from a place deeper than the mind. Of course, its truth is a subjective one, as true as one's perception of oneself in the mirror.[2]

The parallel aims and objectives regarding feminine identity within the first generation, despite their vastly different conceptual approaches to and use of photography, set the stage for a new exploration of photography's function as both record and construct.

Like Sherman, Laurie Simmons' early photographs also critiqued women's roles in modern society. She centered on the narrow ideals of 1950s- and '60s-style feminine domesticity by photographing dolls in tiny kitchens, living rooms, and yards that she had constructed (Plates 13–15). Simmons' images are frankly staged and sometimes eerie, but their humble content also makes them comfortingly familiar. Simmons sometimes contrasted an angst expressed by the dolls (that are occasionally shown falling off chairs or lying on the floor) with the appeal of their cozy settings. Her art is about the seductive quality of memories and stereotypes; she recalls that she even decorated her first apartments to resemble the dollhouses she photographed.[3]

Conceptual artist Eleanor Antin reveled in the new mutability of female identity initiated by the feminist and civil rights movements. She documented her performances exploring this issue in photographs and videos. In the late 1970s, Antin assumed

Figure 3.2
Eleanor Antin. *Myself*, from *The Angel of Mercy*, 1977,
tinted gelatin silver print mounted on paper, 30½ x 22 inches.

the roles of the "King" of a beach in southern California, a ballerina, and a nurse (Plates 10, 11). She felt that the mythologies that defined historical characters such as Florence Nightingale fueled the outsider status of women in the twentieth century. To more fully inhabit—and transform—these characters, Antin dressed in historically accurate costumes and even printed her photographs in period formats such as the *carte de visite*, to make her physical and psychic transformation as authentic as possible (Fig. 3.2). She notes: "Role-playing was about feeling that I didn't have a self, and I didn't miss it. . . . I just borrowed other people's or made them up."[4]

Lorna Simpson worked with Antin (and also with Martha Rosler and Carrie Mae Weems) in the graduate program at the University of California, San Diego. Having concentrated on documentary-style photography as an undergraduate, Simpson eventually adopted a conceptual approach. She created carefully posed photographs in which her black female models' faces are covered, cropped out of the frame of vision, or are turned away from the viewer. Some models are dressed in plain white shifts, others in men's suits (Plates 19, 21). Simpson also replaced models with feminine accoutrements such as wigs. Her evocative imagery—often paired with allusive texts—makes powerful reference to a history of racial and sexual oppression.

Other first-generation photographers sought the immediacy of documentary-style photography to explore the complicated state of contemporary womanhood. Mary Ellen Mark's preference for quirkiness and her on-the-run style of shooting give her images a distinctly raw quality that invokes documentary's traditional goal of exposing the plight of the disenfranchised. In the 1980s, Mark photographed female prostitutes, women confined in a hospital for the mentally ill, and, with a commission in 1983 from *LIFE* magazine, street children in Seattle (Plates 30–33). Mark's connection with "Tiny" in Seattle has extended over many years. Her images of Tiny drinking, despairing over a boyfriend, fighting with her mother, and bathing her children paint the picture of a life that is fraught, complex, and unresolved (Plates 34, 35).

Although she focused on the opposite end of the economic spectrum, Tina Barney shared Mark's goal of revealing a world that is foreign to most of us, if not to her. Like women in John Singer Sargent's paintings, Barney's affluent subjects (who

Figure 3.3
Sally Mann. *The New Mothers*, 1989, gelatin silver print, 18¾ x 23⁷⁄₁₆ inches.

are most often her friends or family members) are ensconced in lavish interiors that signify their identity as much as their clothing, posture, or expression (Plates 22, 23). At Barney's direction, the women stand in doorways and at windows, perch on beds, and repeat unconscious gestures that allude to an underlying emotional discomfiture. Barney acknowledges the tension in her photographs between what seems real and spontaneous and what appears to be fictional and affected, noting, "Nobody will ever know, as I say all the time, what's posed and what isn't. . . ."[5]

Sally Mann's expansive bodies of work depicting children highlight the fact that there can be no single, essential image to express the nature of girlhood. She recorded the wildly varied identities that her models enacted for her. Her pre-teen sitters are alternately worldly and disinterested, or ladylike and ingratiating (Plates 25, 26). Mann's images of her own young daughters from the late 1980s show them similarly choosing their roles: putting on makeup, dangling their candy cigarettes, or mimicking their mother-photographer and taking their baby dolls out for stroll (Fig. 3.3). Throughout the 1980s and early '90s, Mann's and other photographers' emphasis on documenting transitional states of selfhood—from childhood innocence to womanly experience —offered up private narratives for a public increasingly attracted to this type of imagery.

Carrie Mae Weems' art also looked at womanhood, but from a perspective that underscored both the visceral power of documentary photography and the reality problem that plagues it. In her early series *Family Pictures and Stories*, 1978–84, Weems reveled in her immediate family's experiences as positive African American role models using a combination of pictures and texts. She soon began to incorporate postmodern techniques, including tableaux, to develop photographs that express a more inclusive order of truth about family life. In her *Untitled* (Kitchen Table Series), 1990, she combined fictional texts and staged photographs (in which she herself is the central figure) to tell the story of a woman's relationship to her man, their child, and her friends within a domestic setting (Plate 36, Fig. 3.4). The main characters in the images are black, but Weems points out that "the power of the work comes out of the fact that it's not . . . about me. It's about us,"[6] a point reinforced by the viewer's position at the open end of her table.

Working fluidly in a space she then created for herself between documentary and conceptual appropriation, Weems went on to re-present nineteenth-century ethnographic daguerreotypes of enslaved Africans and African Americans in 1995–96, printing them on a large scale and overlaying them with text that alludes to their original insidious purpose—to relate blacks' physiognomy to their perceived level of

Figure 3.4
Carrie Mae Weems, *Untitled* (Woman with friends), from the Kitchen Table Series, 1990, three gelatin silver prints, 27¼ x 27¼ inches each.

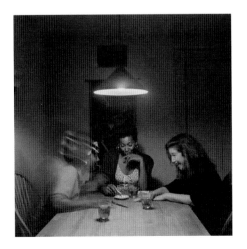

intelligence (Plate 37). These works demonstrated how often and powerfully political ideologies shape our notions and vision of truth, exposing the abuses of "straight" photography while expanding on its capacity for deeper meaning.

THE SECOND GENERATION

While the realms of subjective documentary and postmodern appropriation were relatively discrete in the 1980s, the first generation's provocative inquiries into identity—via gender, race, and sexuality—inspired a new generation of photographers beginning in the mid-1990s. These artists have effectively collapsed the old boundaries between postmodern and documentary photography.

Works by Anna Gaskell, Katy Grannan, Justine Kurland, Nikki S. Lee, Sharon Lockhart, Catherine Opie, Barbara Probst, Collier Schorr, and Angela Strassheim deal with the formation of feminine identity in adolescence or young adulthood, but without the outright critique of the status quo found in the first generation's work. Instead, these artists construct portraits and narratives that thrive on mixed messages and more fluid and nuanced concepts of identity than that of their forebears.[7] No matter how fantastic some of their photographs may be, like the artists of the first generation, these women present images that feel authentic/true. They are often rigorously staged or planned but relate to personal experiences. Although there are touches of humor in some works, they are not ironic. Rather, they are marked by seriousness and even reverence.

Some artists focus their attention on staging performances and preconceived episodes, employing what A.D. Coleman has termed "the directorial mode" to create their photographic productions. Anna Gaskell and Justine Kurland (who both studied with Gregory Crewdson at Yale University in the late 1990s, when Laurie Simmons was also a visiting critic), as well as Sharon Lockhart and Collier Schorr, employ a pastiche of references drawn from art history, film, and theater. With the exception of Schorr, they create male-free worlds that are metaphorical equivalents of contemporary "girl culture."

Anna Gaskell's *wonder*, 1996–97, and *override*, 1997, series are based loosely on tales by the Brothers Grimm and stories in Lewis Carroll's *Alice's Adventures in Wonderland* and *Through the Looking Glass*. Gaskell plays off the hallucinatory qualities of those tales by showing multiple manifestations of the same body, casting her scenes in dramatic light, or staging them in otherworldly settings (Plates 39–42). Her costumed female figures have an eerie grandeur and stillness reminiscent of nineteenth-century portrait photography—including Lewis Carroll's own photographs of girls—in which the subjects are beautifully dressed and wear impassive expressions.

Influenced by nineteenth-century landscape painting and photography, and her personal proclivity for a nomadic existence, Justine Kurland photographs a matricentric world in which women and their children live in harmony—more or less—with the land and with one another. Young girls cluster silently on rocky beaches, and nude women wade through lush woodlands or tuck themselves into the crevasses of waterfalls (Plates 47–50). Kurland finds volunteer models during her road trips to photograph in the American Northwest. She prompts the women to behave not as placid earth mothers but more like naughty girls: "You're running away, you live in trees, you eat nectar, you torture boys, and you're a little bit mean."[8]

Kurland's figures and settings are purposefully gorgeous, as are those of many other artists whose work appears in *Role Models*. Their models' beauty and the splen-

dor of the forests, bedroom-sanctuaries, or sitting rooms that form the backgrounds of their images reinforce the narrative quality of the works and the notion that at some level they are allegories or fantasies.

Sharon Lockhart, who is also a filmmaker, takes some of her cues for her still photographs from cinema. In the late 1990s and early 2000s, she created sequential images of women and girls in opulent interiors and stop-action-style photographs of girls engaged in basketball and other traditional boys' activities (Plates 55, 56). Her figures form friezes across the foreground of the images, and their monumentality is reminiscent of figures in ancient relief sculptures or Renaissance altarpieces. The quietude of Lockhart's images and her engagement with art history draw the focus of her photographs away from polemical statements about gender formation and toward an understanding of the essential grace of humanity.

Collier Schorr is more overt in her explication of gender distinction. In her series *Jens F.*, 1999–2002, an adolescent boy recreates the female attitudes of Andrew Wyeth's Helga pictures (Plates 63–66). In the series, Schorr "set out to create a total portrait . . . [and] to explore how one defines someone in images."[9] Her choice to depict a male from a feminine point of reference was intended to provoke a response from the viewer and also from Jens himself. Schorr noted Jens' extreme self-consciousness: "He's playing this character and the only way he can pose in certain poses is to know that everyone else knows he is playing her, that it's not really him. But you see moments where he forgets. And they're the poses he would call 'neutral' poses, and the feminine poses are the poses that he feels women perform for men."[10]

Works from Angela Strassheim's haunting *Left Behind* series, 2003–05, express ambivalence about the mainstream, girly-girl brand of contemporary American femininity. Distanced from the fundamentalist religious beliefs of her family, Strassheim nonetheless incorporates flowers, butterflies, beams of light, and cruciform poses in her images of young girls in domestic spaces. Each girl enacts her preferred role as mother, princess, or beauty queen. But the viewpoint in many of the images is partially obscured. We peer through a dark yard at lighted bedroom windows or around a partially closed bathroom door to see the girls (Plates 68, 69). Strassheim's training as a forensic photographer is evident as she stages her photographs to make it feel as though we are discovering a secret, girl-made world.

German-born Barbara Probst eschews detailed narratives, shooting attractive,

Figure 3.5
Barbara Probst. *Exposure #18: N.Y.C., 498 7th Ave., 12.16.03, 13:29 pm*, 2003, Ultrachrome ink on cotton paper, 4 parts, 44 x 29½ inches each.

smartly clad young women in pristine photography studios or against the open skies above New York City's rooftops (Plates 61, 62; Fig. 3.5). Her photographs capture the essence of East Coast-style glamour, but from an outsider position. By minimizing details, she presents us with an iconic vision of the savvy and adventurous American urbanite. Probst's images suggest that her subjects—and perhaps all of us in the early twenty-first century—are suspended somewhere between the "real world" and the imaginative realms of photo shoots and movie-making.

For all of these artists, subjective documentation and allegorizing narratives fold into one another so seamlessly that it is difficult for the viewer to determine to what degree a photograph is "real" or "posed." Other photographers of this new generation have worked in a more deliberately objective vein to represent themselves and others. Their work is often infused with postmodern goals and techniques, however, and distinctions between real and posed remain unclear.

Documentary photographers from America and abroad are featured in contemporary photography shows and fairs alongside those working in a more conceptual manner. One documentarian is South African-born photographer Michelle Sank (Fig. 3.6). She accepts commissions in the manner of the mid-twentieth-century photo essayists, and she has documented the plight of girls in youth shelters and teenaged mothers, but a more recent series records the ways in which young girls and boys interpret masculinity and femininity. Sank's works are characterized by high-keyed color, intense lighting, and stark backgrounds that draw them close to the art of more explicitly conceptual artists.

In her works in *Role Models*, Catherine Opie focuses on codes of gender representation as she documents her life in gay, lesbian, and S&M friendship circles as the quintessential insider. Yet a stylish polish sets her photographs apart from the realities of her imagery. Like Sank, she uses lighting, color, and scale to dramatize her images (Plates 57–60). Some, such as those presenting her self-mutilated body, are difficult

Figure 3.6
Michelle Sank, *Jolene*, from *Teenagers Belfast*, 2005, chromogenic print, 19¾ x 19¾ inches.

to view. With regard to her work, which includes subjects ranging from suburban land-scapes to surfers, Opie observes: "I feel like I am going around picking things apart, forcing people to look at places and communities that they really don't want to look at. Yet, I want to look at these places and at those communities."[11]

Korean-born Nikki S. Lee seeks to become an insider by adopting the gestures and appearances of diverse American subcultures (Hispanic, hip-hop, skateboarders, or exotic dancers) that she experiences over a period of weeks or months (Plates 51–54). She selects the activities that she wants to be photographed, but she hands her camera off to whoever is standing nearby to ensure a kind of artlessness in her images that will make them feel more "real" to viewers.[12] In some photographs, Lee does not register very distinctly from other figures; in others, her Asian identity stands in high contrast to those around her and foregrounds her outsider status. Lee's willful pursuit of multiple personae exposes the fluidity of identity formation in contemporary American culture.

In contrast to the performative essence of Lee's art, Katy Grannan's photographic process replicates the conditions of a detached observer—at least initially. She places ads in small-town newspapers to photograph people she does not know. She ultimately becomes involved in the most intimate of insider situations, as she asks her subjects to choose how they will pose. Grannan's sitters seem to anticipate and respond to social expectations about beauty, femininity, and sexuality, posing and selecting their degree of undress accordingly (Plates 44–46). The young women in Grannan's photo-graphs often exude defiance. Gazing straight out of the compositions, they seem to dare us to critique the identity they have shaped.

Whatever direction these young photographers take, they all recognize that they are speaking with a constructed voice, mediated by internal needs and external demands along an axis between a realized and idealized self. As *Role Models* makes clear, understanding one's role and its mutability in the face of the world at large—a significant aspect of identity formation—has been central to the art and social function of contemporary American photography from the 1980s to the present day.

1. Susan Sontag, *On Photography* (New York: Anchor Books Doubleday, 1990), 177. She continues, "On the one hand, cameras arm vision in the service of power—of the state, of industry, of science. On the other hand, cameras make vision expressive in that mythical space known as private life."

2. Lauren Greenfield, *Girl Culture* (San Francisco: Chronicle Books, 2002), 149.

3. Laurie Simmons, "In and Around the House," in Carol Squiers and Laurie Simmons, *In and Around the House* (New York: Carolina Nitsch Editions, 2003), 22.

4. Quoted in Susan Sollins, *Art:21* (New York: Harry N. Abrams, 2003), 115.

5. Faye Hirsch, "Inside People: An Interview with Tina Barney," *Art on Paper* 3 (May–June 1999): 49.

6. Quoted in Susan Benner, "A Conversation with Carrie Mae Weems," *Artweek* 23 (May 7, 1992): 5.

7. Elizabeth Armstrong observes that this impulse extends to photographers beyond the U.S.: "[W]omen today are able to explore complex and contradictory notions of femininity without having to defend or valorize past feminist gen-der issues, and they are consequently more likely to define identity in more ambiguous terms, drawing on their own subjectivities and multiple potentialities" (Elizabeth Armstrong, "Girl, Unmasked," in Elizabeth Armstrong, Taru Elfving, and Bill Horrigan, *Girls' Night Out* (Newport Beach, California: Orange County Museum of Art, 2003), 16).

8. Quoted in Anne Stringfield, "Two for the Road," *Vogue* (February 2007): 164.

9. Collier Schorr, "'Jens F./Helga' project by Collier Schorr," interview in *Art:21–Art in the Twenty-First Century, Seasons One and Two* (PBS DVD Video: 2003).

10. Ibid.

11. Maura Reilly, "The Drive to Describe: An Interview with Catherine Opie," *Art Journal* 60 (Summer 2001): 93.

12. Russell Ferguson, "Let's Be Nikki," in *Nikki S. Lee Projects* (Ostfildern-Ruit, Germany: Hatje Cantz Publishers, 2001): 9.

Plates

Plate 1.

Cindy Sherman. *Untitled #96,* **1981.**

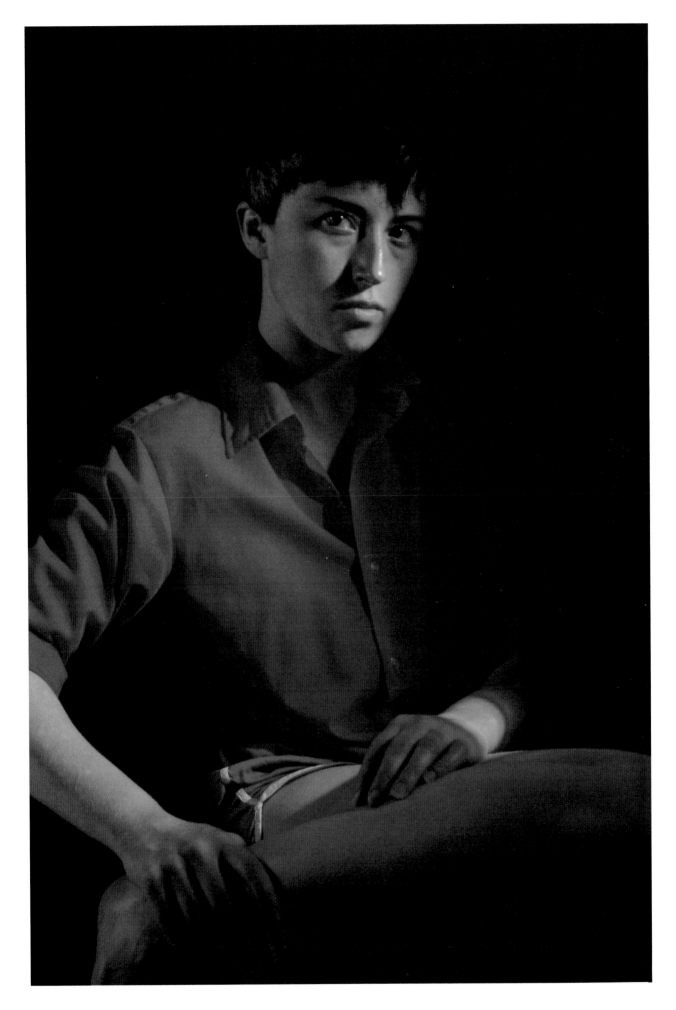

Plate 2.

Cindy Sherman. *Untitled #112*, 1982.

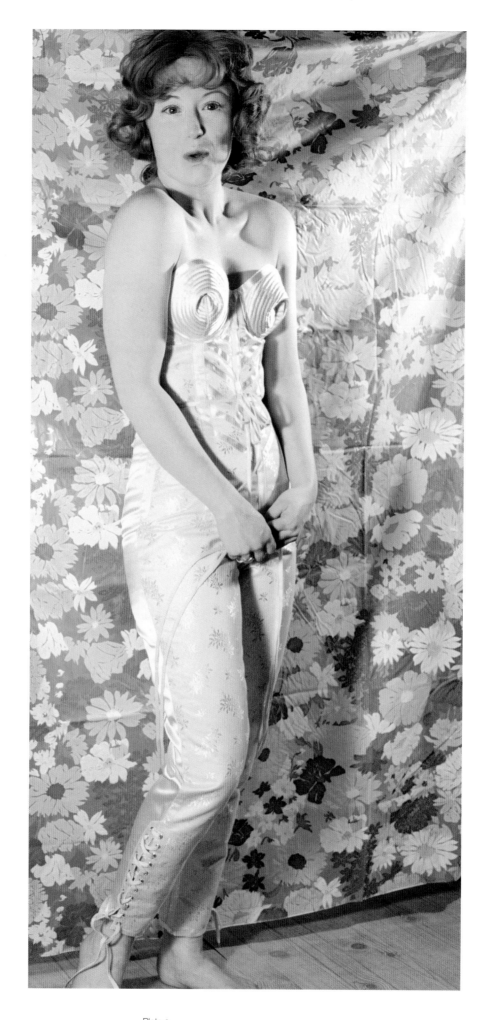

Plate 3.

Cindy Sherman. *Untitled #131*, 1983.

48

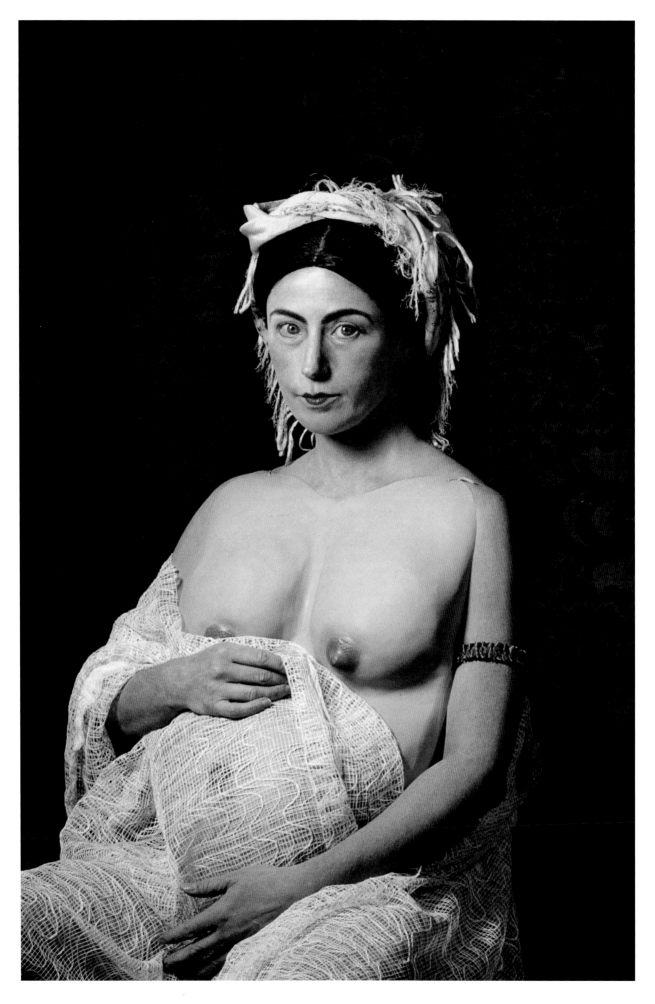

Plate 4.

Cindy Sherman. *Untitled #205*, 1989.

49

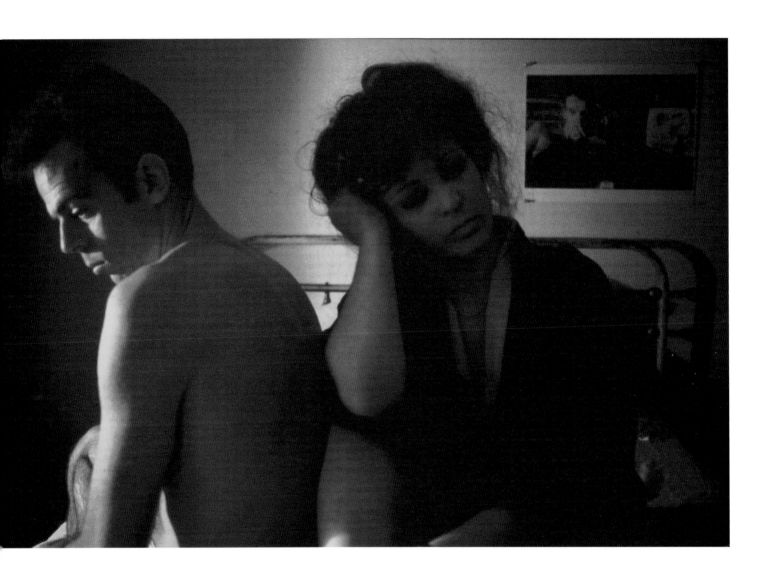

Plate 5.

Nan Goldin. *Self-portrait in kimono with Brian, NYC*, 1983.

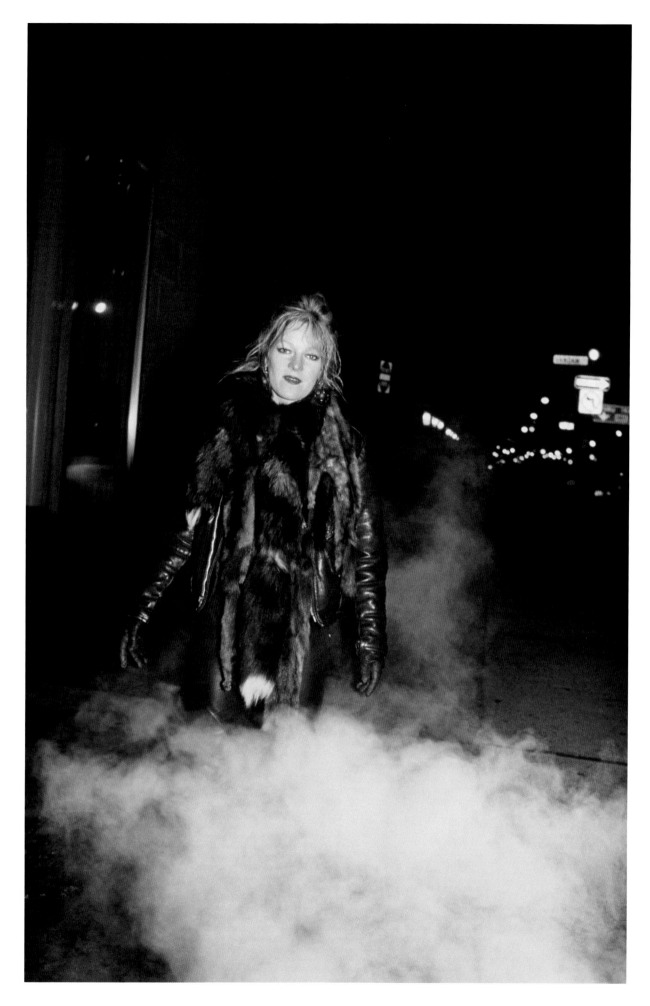

Plate 6.

Nan Goldin. *Cookie in the NY inferno, NYC, 1985.*

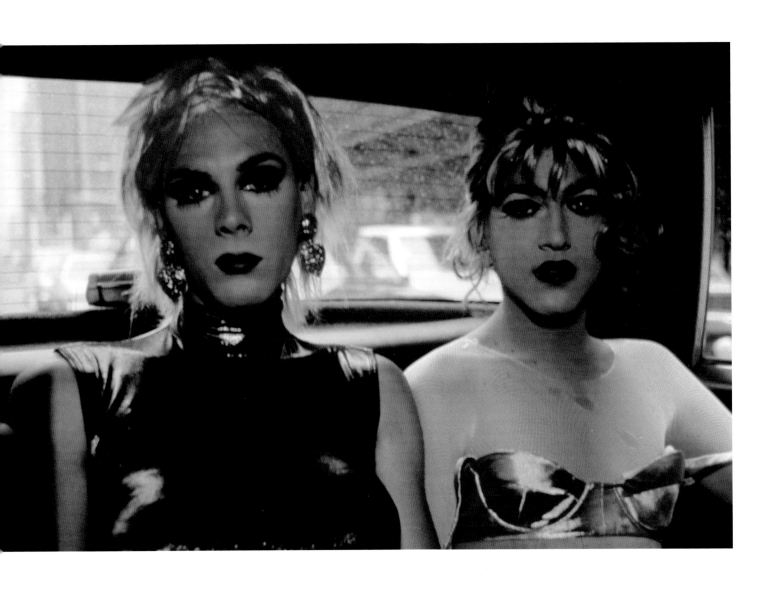

Plate 7.

Nan Goldin. *Misty and Jimmy Paulette in a taxi, NYC*, 1991.

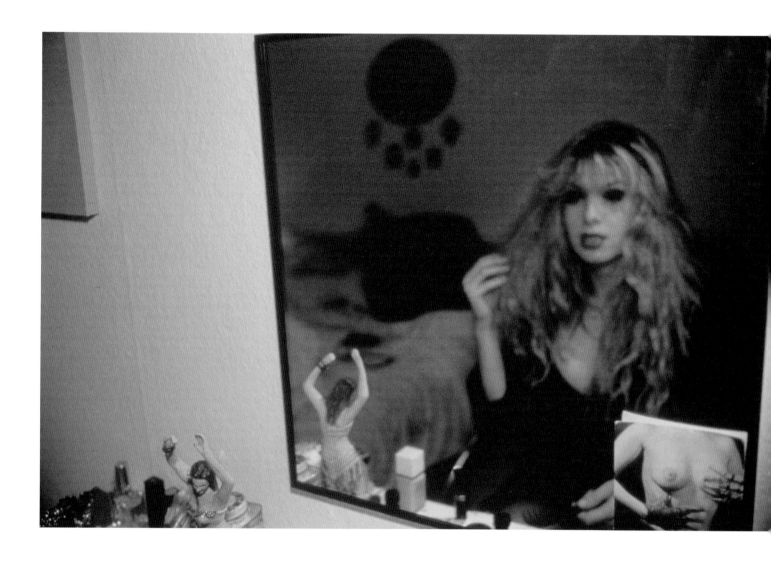

Plate 8.

Nan Goldin. *Joey in my mirror, Berlin*, 1992.

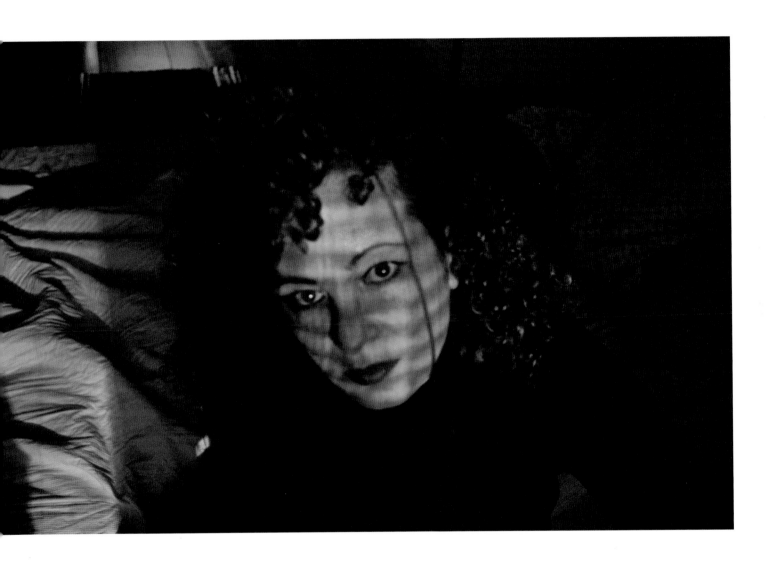

Plate 9.

Nan Goldin. *Self-portrait on my bed, Berlin,* **1994.**

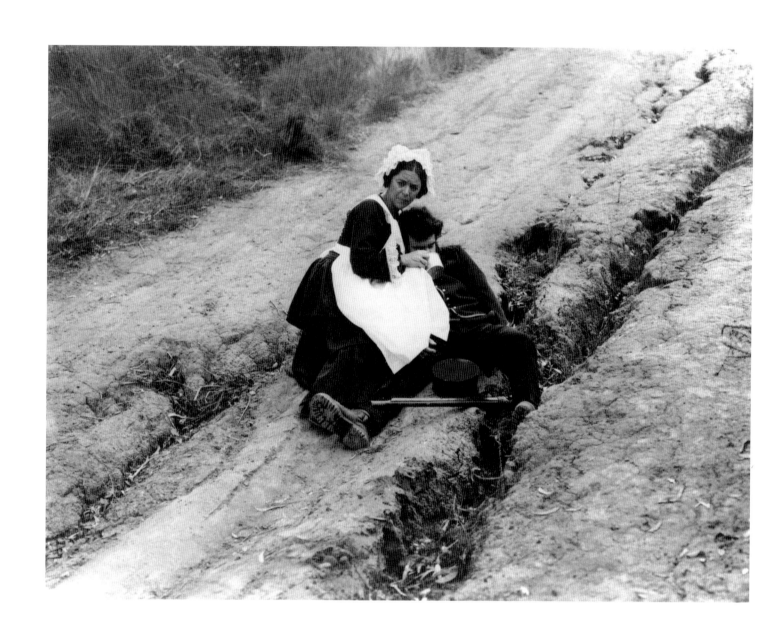

Plate 10.

**Eleanor Antin. *The Angel of Mercy*, from *The
Angel of Mercy*, 1977.**

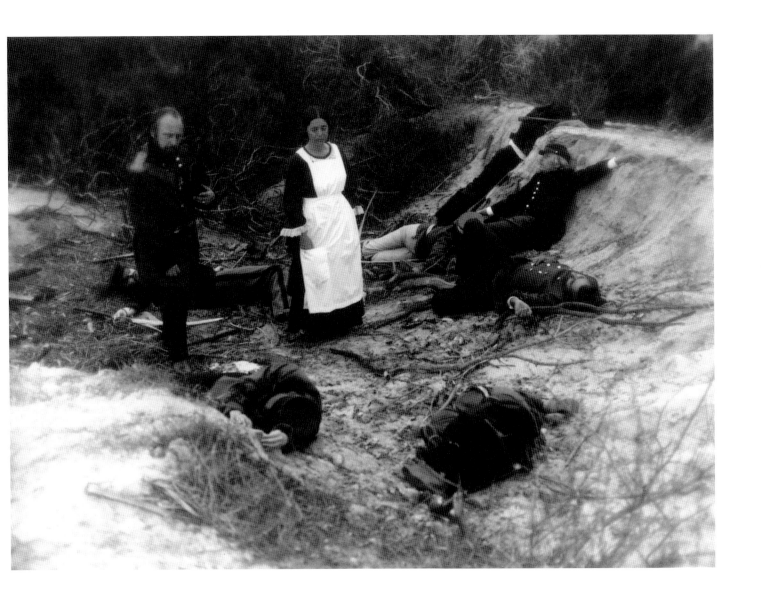

Plate 11.

**Eleanor Antin. *In the Trenches before Sebastopol,
from The Angel of Mercy*, 1977.**

57

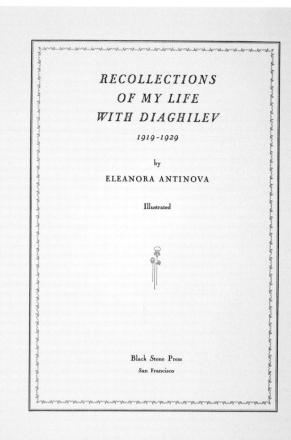

RECOLLECTIONS
OF MY LIFE
WITH DIAGHILEV
1919-1929

by
ELEANORA ANTINOVA

Illustrated

Black Stone Press
San Francisco

Pocahontas was the first ballet choreographed for the *Ballets Russes*. The role of the ill-fated Indian Princess was chosen for my debut because it appeared to address itself to both my darkness and my Americanness. Unfortunately, the scenario was Benois' fantasy of primeval forests and Elizabethan England – more Petipa than Longfellow.

The scenario called for us to begin with the death of Pocahontas in an English tavern, so we had to dance the story backwards – no mean feat for deaf mutes. I hit upon the idea of installing two stage levels so I could compress the action into an Elizabethan present and a Virginia flashback.

The Elizabethans caroused on the lower level, bear-baiting, pocket-picking, tumbling, doing jigs, hornpipes, morris dances, while I made delirious gestures from a bed on the upper level, which Benois had painted to represent a timbered balcony. Later, I threw off my diaphanous bedclothes and leapt out of bed in my Indian costume to dance the dream of my youth. This flashback included a fancifully constructed dream boat, sailing over waves represented by a rope held by two dancers, who flailed it around to cook up a balletic storm. A couple of steals from Shakespearean theatre practice brought a stealthy forest to my bedside, and some ethnic types from the lower level performed a dumb show of my nuptials with a stiff-necked British farmer.

The dress rehearsal was a debacle. They quite forgot the plot was of their invention, not mine. Diaghilev flew into a rage and threw out most everything – the two stage levels, the bed, the boat, the forest, the wedding. The final version found me lying on the stage, obscured by revellers brawling and twirling to some Russian version of Elizabethan music. At some point – for no reason known to anyone – the crowd parts to reveal me lying flat on my back, waving my arms helplessly above me. When I rise – bow and arrow in hand – to dance the delirium dream of my youth, expressed mainly by spins, leaps and cartwheels, two dancers, heavily padded in front, grasp opposite ends of a long rope, and for reasons mysterious to everyone, wave it gracefully in the air until I collapse and die.

The shortened version had some success and stayed in the repertoire for a couple of years. It was revived once by the de Basil company and there was some talk of reviving it again for the recent Bicentennial, but it came to nothing.

[190]

Plate 12.

Eleanor Antin. *Recollections of My Life with Diaghilev 1919–1929*, 1976–78.
(above) **cover.** (below) **I. Pocahontas.**

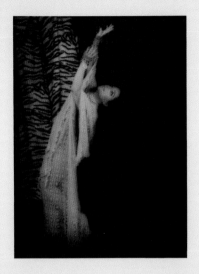

Tʜɪs was my first success — *l'Esclave* — a solo number I performed at some of the smartest salons around Paris.

I had met a young French poet, Jean Meunier. He was my first poet. All my life I have had a taste for poets. Jean had a *folie*. He believed that in a previous life he had been Baudelaire. That is, he said he believed it. He still signed his poems, Jean Meunier. He would recite from *les Fleurs du Mal* in those dark glamorous tones the French use for poetry and I fell into the habit of dancing along with him. He soon discovered that I must be Jeanne Duval, his dusky mistress from Martinique, and the inspiration for the Black Venus poems.

Hers was a sad story. In the name of love, Baudelaire spirited her away from an incipient theatre career and locked her up in a dark little apartment, where he visited her daily to indulge what the French call complicated tastes. Since she had nothing else to do all day but receive him, she soon became a drunk and he became a drug addict. Naturally, my sympathies were with the darker rather than the lighter wreck.

From the beginning my dance felt more like a long transition or slow motion stage direction than anything else. I was so overcome with the liberating elements in my piece — my crouched body, wrists in chains, facing stage right, beginning with almost painful slowness to reverse its direction until it had turned 180° to face stage left — the pleasures of liberating the individual parts of my body, which began to move independently — my head, shoulders, chest, arms and hands, hips, legs, knees even — that I failed to realize I was moving everything but my feet.

What kind of a dance was that? A preposterous dance! I was the only dancer in the world to do a stationary dance.

Luckily, the artists adored its self-referential ironies. I myself preferred its representational accuracy. After all, poor Jeanne had had only a narrow space in which to move. The constrictions of her life became the restrictions of my dance.

The young have a talent for being in the right place at the right time. It was during a performance at Misia Sert's apartment on the *Quai Voltaire* that I met Diaghilev and he invited me to join his company. I could never figure out why, since ballet is all about feet. From this dance — who would know that I had any?

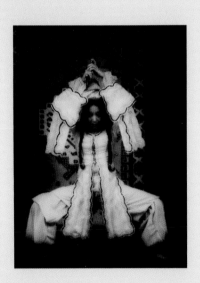

As for *Prisoner of Persia*, the less said about this one, the better. It was a pot-boiler from start to finish.

The old Fokine ballets — *Scheherazade, Cléopâtre, Oiseau de Feu, Petrouchka* — supported us, I daresay, almost single-handedly. They paid for the modern ballets acclaimed by the fashionable people. So when *The Sleeping Princess* revival in London just about bankrupted the company, Diaghilev, at his wits end to raise some quick money, asked me to do an Arabian ballet. He didn't dare ask Nijinska or Massine, and it being about two years since my last ballet, I was hardly in a position to refuse.

Scheherazade was, as everybody knows, based upon Delacroix' *Death of Sardanopolis*. Modern audiences also enjoyed seeing beautiful women and handsome black men massacred by soldiers in turbans. To add a little spice to the usual fare, I merely reversed the roles.

In my ballet, the Shah and his soldiers recline on opulent pillows, smoke opium and dream to the melancholy airs of flute boys. The harem beauties, abandoned to their own devices, take up gymnastics, dancing, sports, hunting, to amuse themselves. When they take up war and revolt, the Amazons easily defeat the helpless men. I even used Mr. Fokine's choreography in the massacre scene. The only real difference was that in this one, it was the harem wives who swung the swords — and with the abandon for which the company was famous. In those days the girls didn't get to do *double tours en l'air* so they all enjoyed themselves thoroughly, which is rare indeed — especially for Russians, more disposed to pain than pleasure.

We were certain of success. I dreamed of designing my next ballet for the generous Madame Ida Rubinstein. I had a notion she would make a fascinating Theodora and we could pull off a spectacular gladiator scene. If I was to be corrupted by success, I would go all the way. My fortune was made.

Much to our surprise *Prisoner of Persia* was received very badly. So badly, in fact, it was dropped from the repertoire after only several performances. It was with no little chagrin that I returned to being a dancer again.

(above) **II. *L'Esclave*.** (below) **III. *Prisoner of Persia*.**

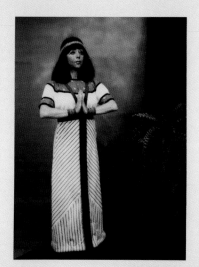

IV. *Hebrews.*

EVERYBODY was talking about Industrial Technology. Progress, futurism, were all the vogue.

But the sets of Gabo and Pevsner or Yakoulov for *le Pas d'Acier*, and *la Chatte* were expensive. So they asked me to do another exotic ballet, this time in line with the current Egyptian craze. *The Hebrews* would be a Moses ballet and I would be the daughter of Pharoah who found Baby Moses in the rushes.

They sent me to Egypt to soak up the local color. Balancing on my camel, I wondered how they dragged those heavy stones to the top of the pyramids. After all, unlike the nasty Greeks or Assyrians, say, the Egyptians appeared to be an amiable people concerned with baking bread and bricks, with only an occasional murder. Those countless factories of bakers, weavers, boat builders, scribes, looked like technology to me. They seemed to enjoy labor too much to exploit it. Ideas began to percolate. Was I to be the first to do a historical *ballet mécanique*?

Returning to Paris, I made a secret trip to the studios of Leger and his friends. A week later, I slipped into Germany to study the new theatre of Kreutzberg and Joos. I was careful not to be observed by the spies Rubinstein and Massine were said to have circulating in the most unexpected places. No point in my ideas being stolen before I was credited with them. If I couldn't be rich, at least I should be famous!

But on the other hand if I was forced to enter the modernist mode by the back door, history would surely have to be told what was what. The lamentations of Bakst, Benois, Stravinsky, Fokine, Cocteau, the Nijinsky's, haunted the Russian Ballet. If they, looking to all the world like fortune's favorites, felt ill-treated, certainly, I, without patrons, would have to look after myself by all means. History was alternately too hare-brained and too interested a party to leave to her own devices. Small wonder Picasso chose to have poets for friends!

I choreographed group dances in which each dancer was merely a stiff cog in a great wheel. It was the principle of the assembly line, each dancer repeating the same small action in regular rhythmic patterns. There was a mimed hum and buzz of regulated activity. Ballet is a machine really, so the dancers fell easily into their rotating slots, and not without a certain pleasure in self-annihilation. It was all very modern.

This time we were sure to have a success!

Unfortunately, we were defeated by the surface similarities to the old exotic ballets. Once again the simplicities of the world of art confounded me. Machinery belonged in a futurist setting. Only the murder of the overseer by Moses belonged in our ancient one.

The Hebrews was removed from the repertoire at the end of the season and has never been revived.

[192]

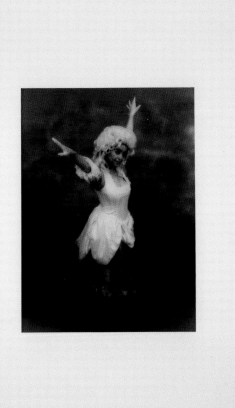

Before The Revolution was my most famous, perhaps my least understood work. Since it is still revived occasionally there is hardly any need to describe it. Contemporary audiences can judge for themselves. Alas, they usually can't make head or tail of it; but the inadequacies of the world of art are well known and I have long since ceased caring.

For me, the White Queen dancing through the empty streets of peasant villages and dairy farms was the spirit of ballet – as the flightless white birds gliding swiftly over the little pond in the shadow of the *Hameau* were its soul. I visited the deserted little *Trianon* and, if I half closed my eyes, I could make myself believe the suave necks of the great birds were at that very moment curved languorously over the coaxing hand offering cake crumbs and pieces of sugar. So did I also imagine myself to be the White Queen while feeding the scruffy swans in the *Bois de Bologne* that Winter I lived in the small hotel with the white columns off the *Pont de Saint-Cloud*. How graciously we bowed to each other, for all the world as if neither fleas nor grease lined the undersides of their dirty white feathers, or the rancid memories of sweat and grease paint were not permanently soaked into my skin. As tenderly did Anna Pavlova, wrapped in ermine like a mummy, stroke *her* swans at Ivy House that frosted afternoon we were invited down from London. Later that season, with a last flutter of those remembering hands, the immortal swan was to die during a snow storm in Amsterdam. The pale face sank into the eiderdown pillows of the Dutch bed. "Marguerite, lay out my swan costume." Swans are celebrated for their dying.

Marie-Antoinette was my balletic swan song. It was my last choreographed work, since it was produced during what turned out to be our final season: Diaghilev died soon after in Venice. For a short while we came together – the White Queen and the Black Ballerina – and we made a preposterous but by no means impossible fit. "Type casting is vulgar," announced the elegant little Queen slipping into the silk flounces and ivory petticoats of a shepherdess. Out there at the boundaries, at the edges of the possible, sometimes they may come together, the desire and the fact. There where the artist intersects with her ambitions, there at the precipice, I dared to stake my claim.

Unfortunately, ballet is dedicated to a fantasy of purity and classical correctness. It is even worse now than it was then. Today, I should not be able to get a foot in the door. I would be too eccentric and high colored for the mindless machines Balanchine has turned loose – like ants.

[193]

(above) **V. Before the Revolution.** (below) **VI. Paris Life.**

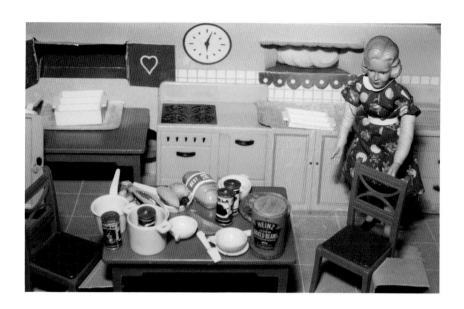

Plate 13.

Laurie Simmons. *Blonde/Red Dress/Kitchen*, 1978.

Plate 14.

Laurie Simmons. *Pushing Lipstick (Full Profile)*, 1979.

Plate 15.

Laurie Simmons. *Woman/Green Shirt/Red Barn*, 1979.

Plate 16.

Laurie Simmons. Suzie Swine, 1987.

Plate 17.

Laurie Simmons. *Walking Cake II*, 1989.

Plate 18.
Laurie Simmons. *Music of Regret IV (color)*, 1994.

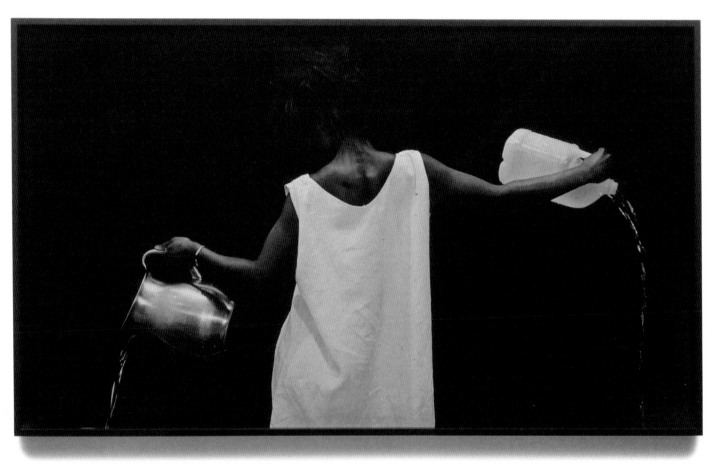

SHE SAW HIM DISAPPEAR BY THE RIVER,
THEY ASKED HER TO TELL WHAT HAPPENED,
ONLY TO DISCOUNT HER MEMORY.

Plate 19.

Lorna Simpson. *Waterbearer*, 1986.

braid into four circles

over-hand
under-hand
whichever you prefer

part into eight sections
from the crown

each section is twisted anti-clockwise

a hair piece is
attached to the crown

braids meander over
entire head

a section of hair is parted
and held firmly
between left thumb & forefinger

starting just behind the ears

tips of each strand are connected
until they form a circle

the transverse braids from
a series of zig-zags

Plate 20.

Lorna Simpson. *Coiffure*, 1991.

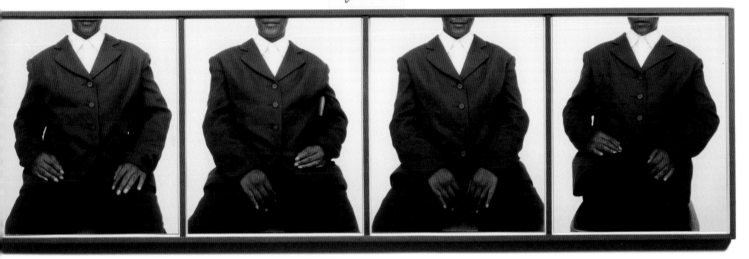

Plate 21.

Lorna Simpson. She, 1992.

Plate 22.

Tina Barney. *Jill and Polly in the Bathroom, 1987.*

Plate 23.

Tina Barney. *Marina's Room*, 1987.

Plate 24.
Tina Barney. *Thanksgiving,* **1992.**

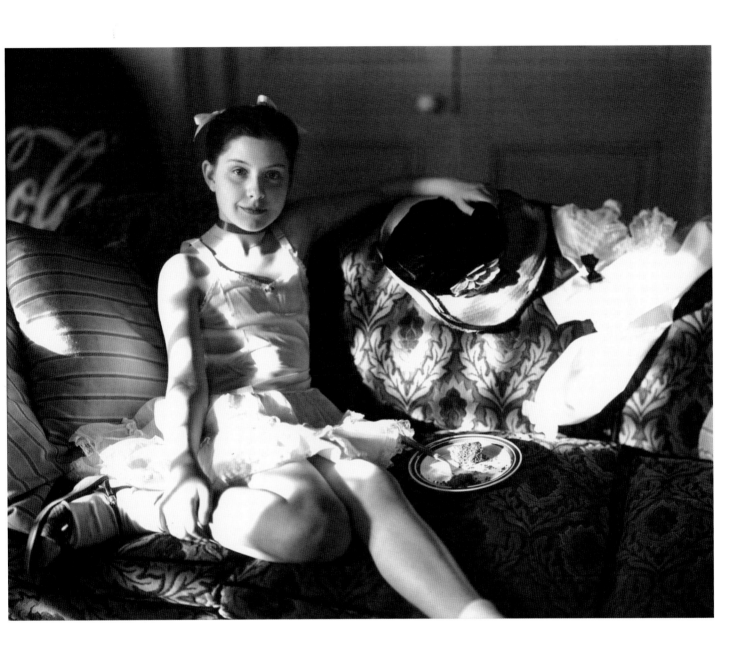

Plate 25.

Sally Mann. *Lithe and the Birthday Cake*, 1983–85.

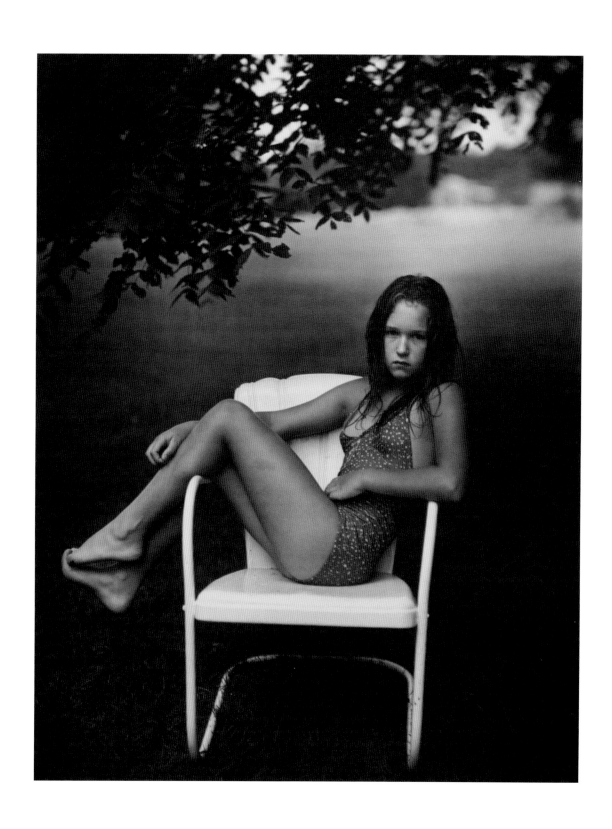

Plate 26.

Sally Mann. *Juliet in the White Chair*, 1983–85.

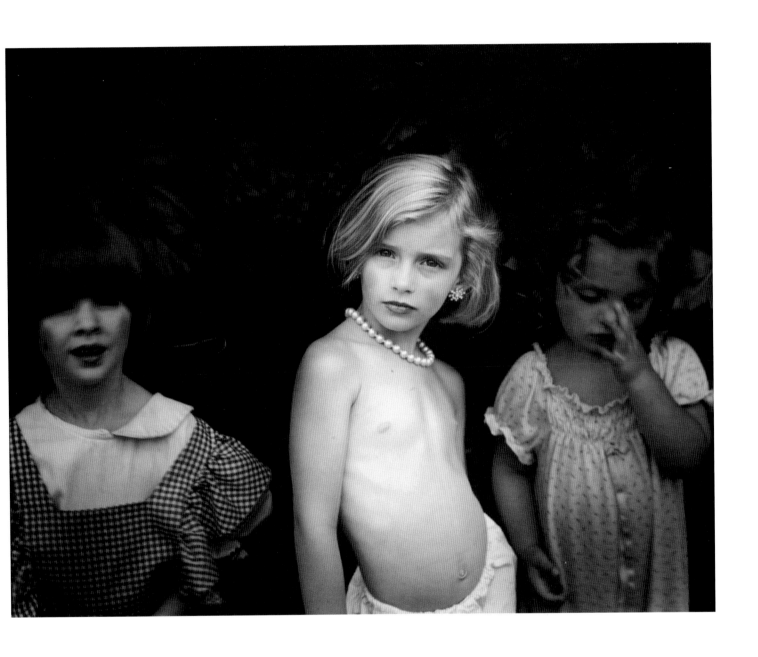

Plate 27.

Sally Mann. Jessie at 5, 1987.

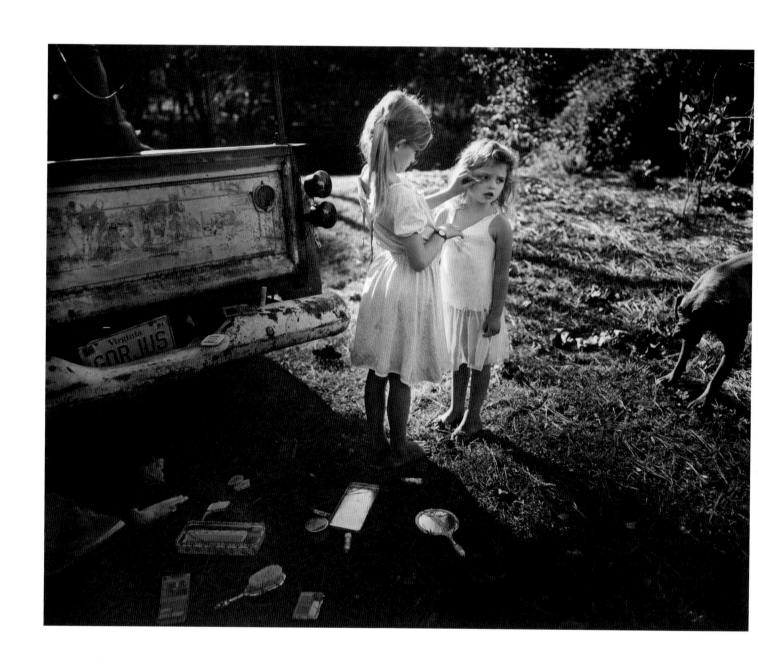

Plate 28.

Sally Mann. *Gorjus*, 1989.

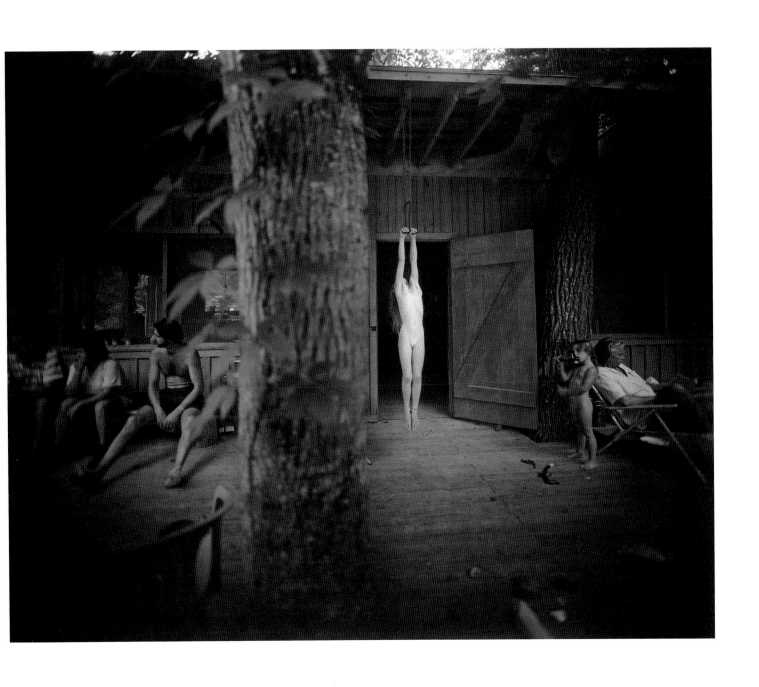

Plate 29.

Sally Mann. *Haynook,* **1989.**

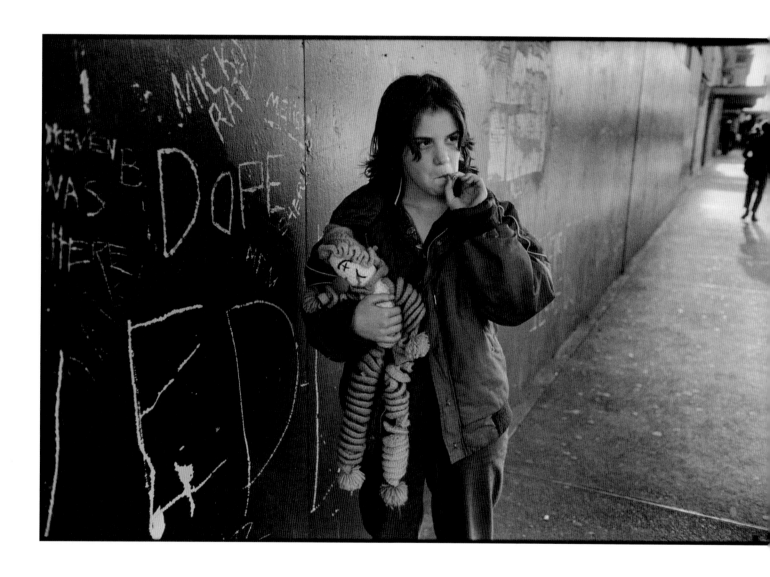

Plate 30.

Mary Ellen Mark. *Lillie with Her Rag Doll, Seattle*, 1983.

Plate 31.
Mary Ellen Mark. *Patti and Munchkin, Seattle, 1983.*

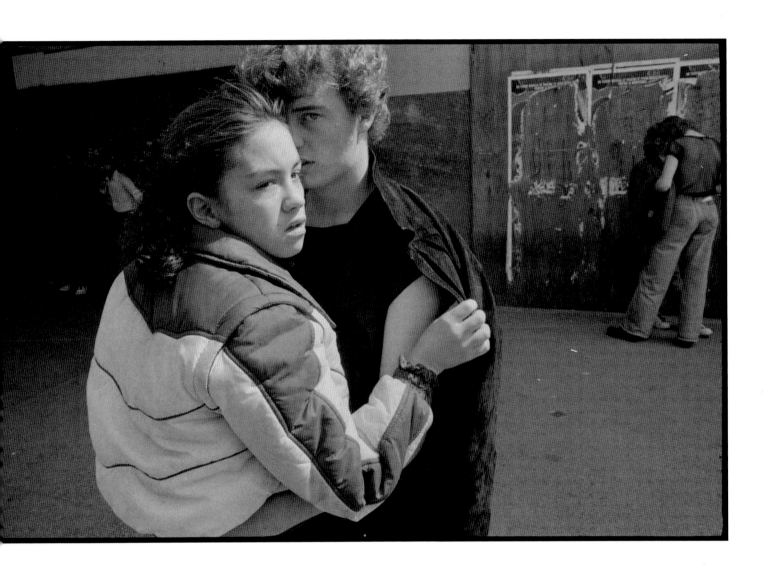

Plate 32.

Mary Ellen Mark. *Tiny in Her Halloween Costume, Seattle*, 1983.

Plate 33.

Mary Ellen Mark. *Tiny in the Park, Seattle*, 1983.

Plate 34.

Mary Ellen Mark. *Tiny and Her Mother Fighting,*
Seattle, 1999.

Plate 35.

Mary Ellen Mark. *Tiny in the Bathroom with Ray Shon and Tyrese, Seattle, 2003.*

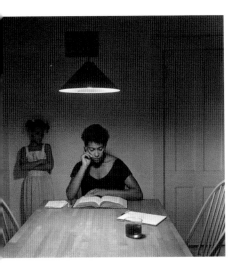 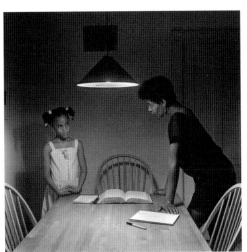 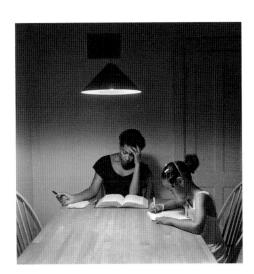

Plate 36.

Carrie Mae Weems. *Untitled* **(Woman with daughter),**
from the Kitchen Table Series, 1990.

Plate 37.

Carrie Mae Weems. *From Here I Saw What Happened and I Cried (House, Field, Yard, Kitchen),* 1995–96.

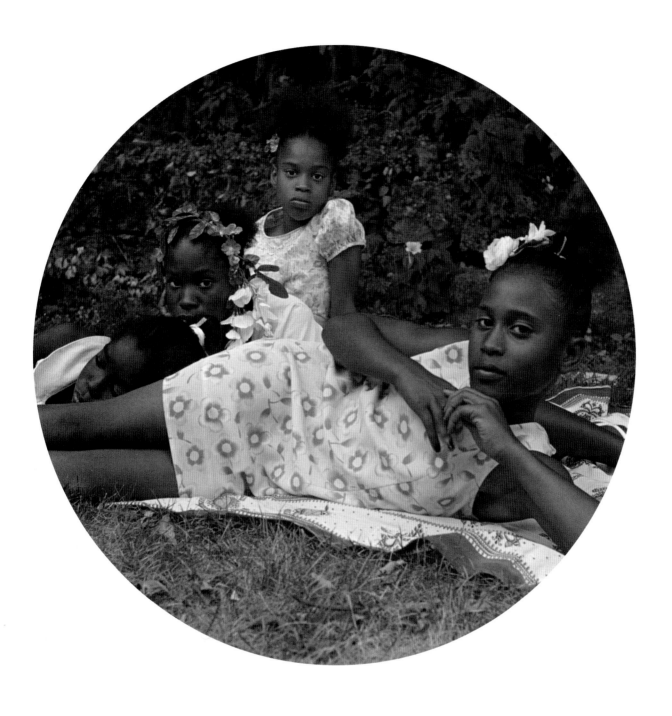

Plate 38.

Carrie Mae Weems. *After Manet*, from the series *May Days Long Forgotten*, 2003.

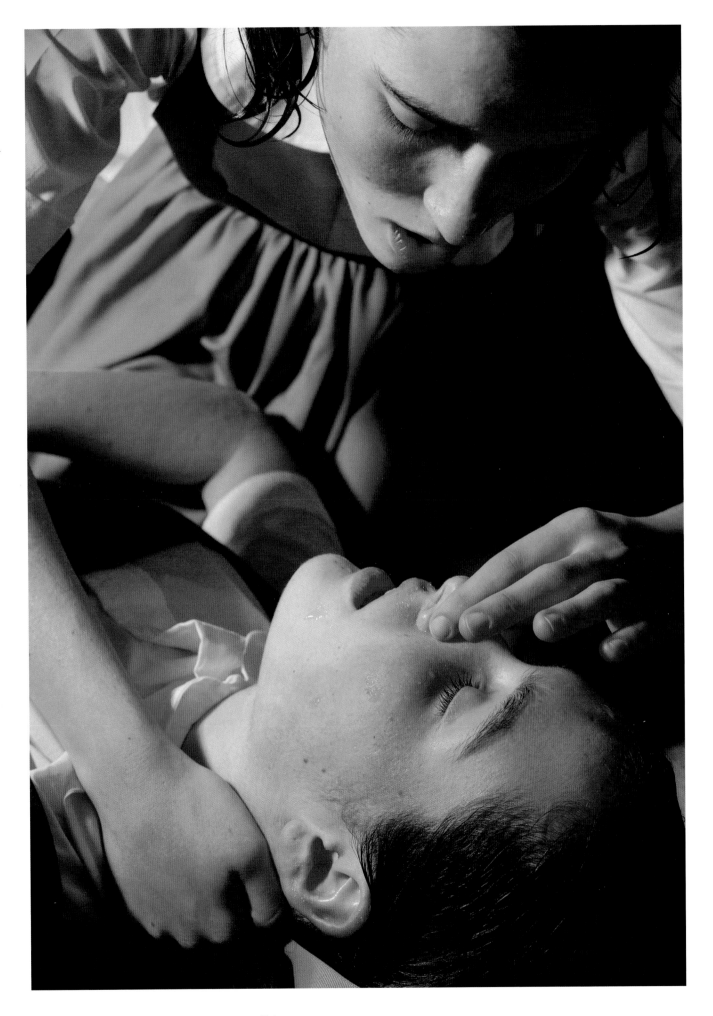

Plate 39.

Anna Gaskell. *untitled #2 (wonder)*, 1996.

91

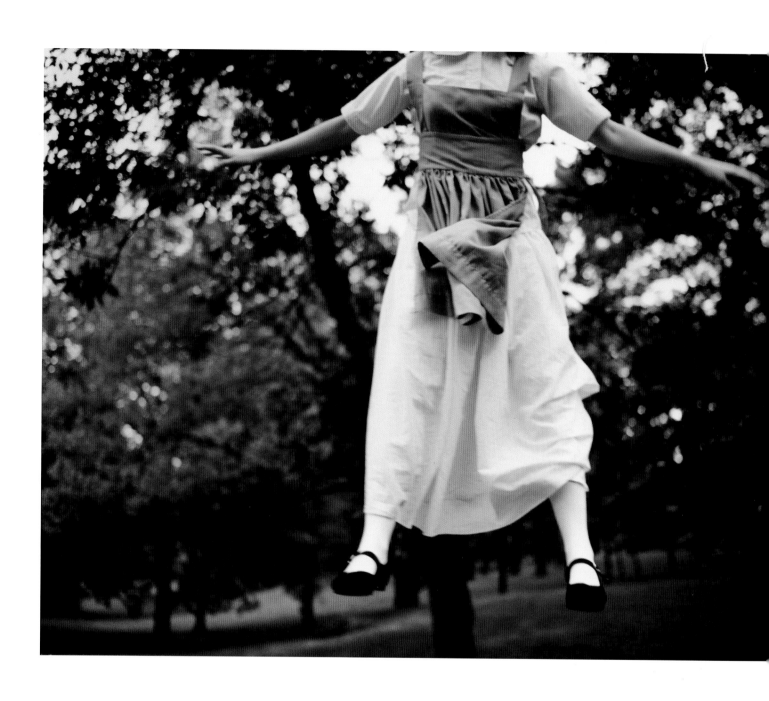

Plate 40.

Anna Gaskell. *untitled #6 (wonder)***, 1996.**

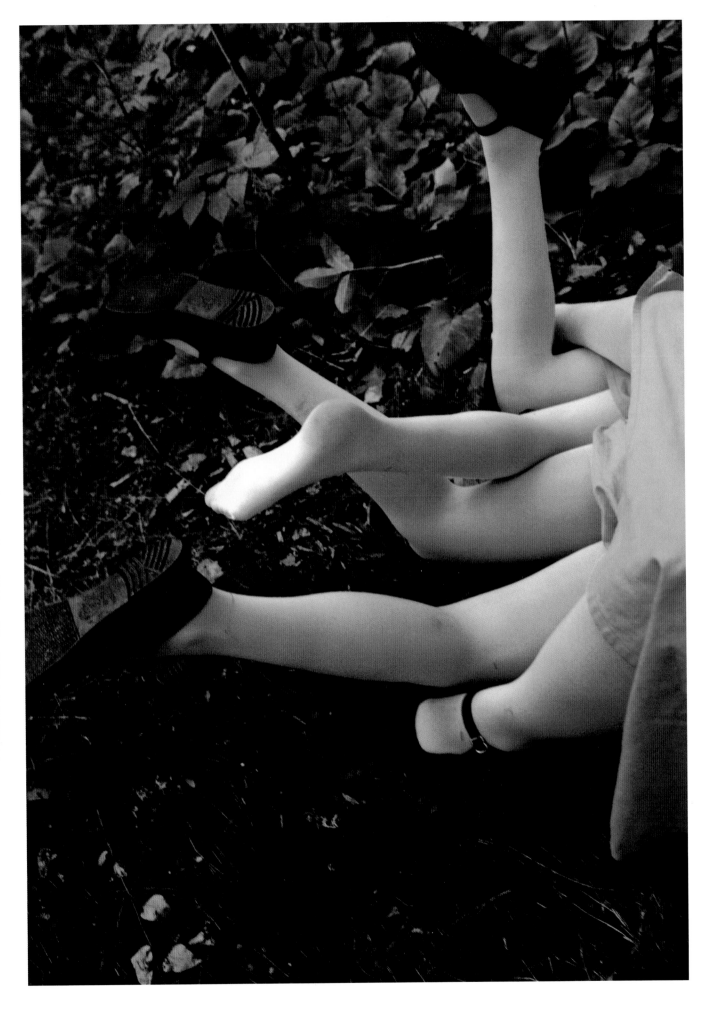

Plate 41.
Anna Gaskell. *untitled #25 (override),* **1997.**

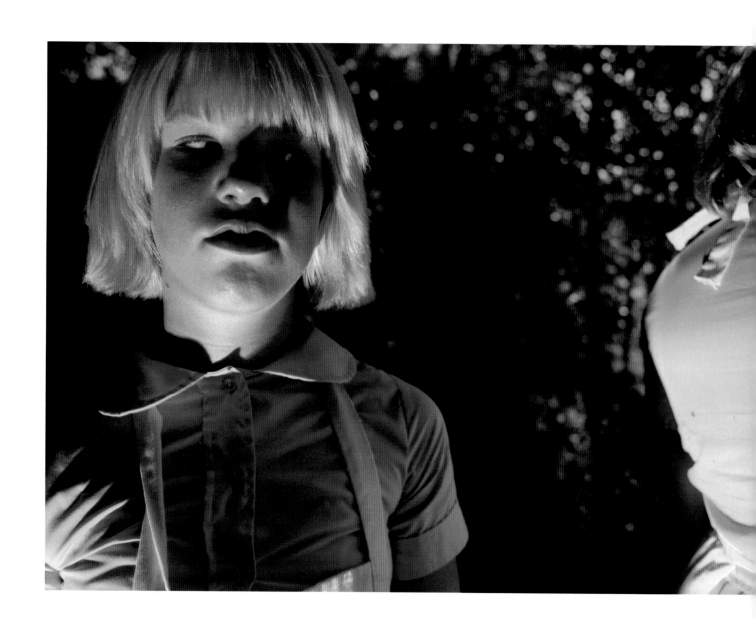

Plate 42.

Anna Gaskell. *untitled #26 (override),* **1997.**

Plate 43.

Anna Gaskell. *untitled #69 (by proxy)*, 1999.

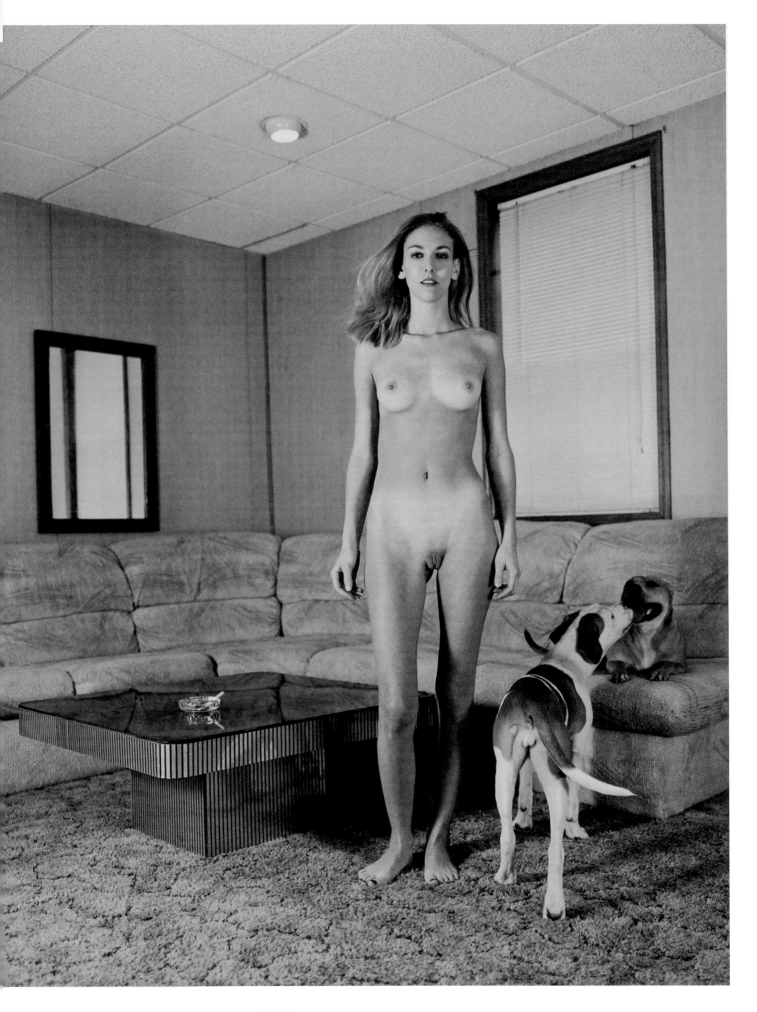

Plate 44.

Katy Grannan. *Pleasant Valley, NY, 2002.*

97

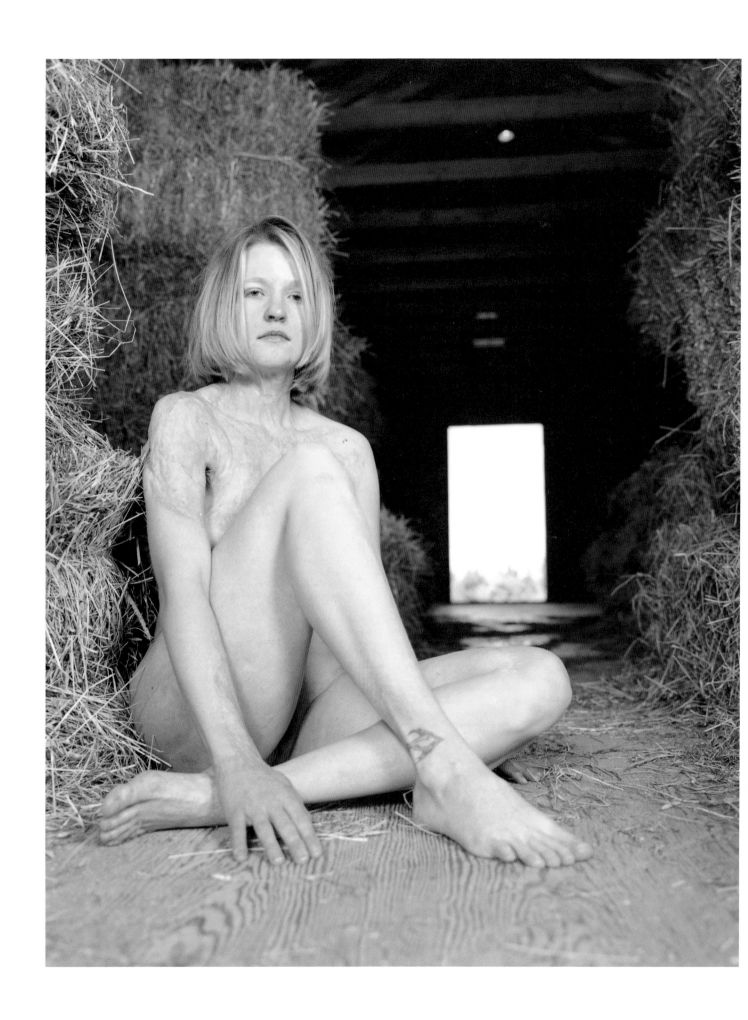

Plate 45.

Katy Grannan. *Untitled* (from *The Poughkeepsie Journal*), 1998.

Plate 46.

Katy Grannan. *Taryn & Bird, Pinardville, NH, 2003.*

Plate 47.

Justine Kurland. *Cyclone*, 2001.

100

Plate 48.

Justine Kurland. *The Pale Serpent*, 2003.

Plate 49.

Justine Kurland. *Self-Portrait with Casper, Texas Canyon*, 2006.

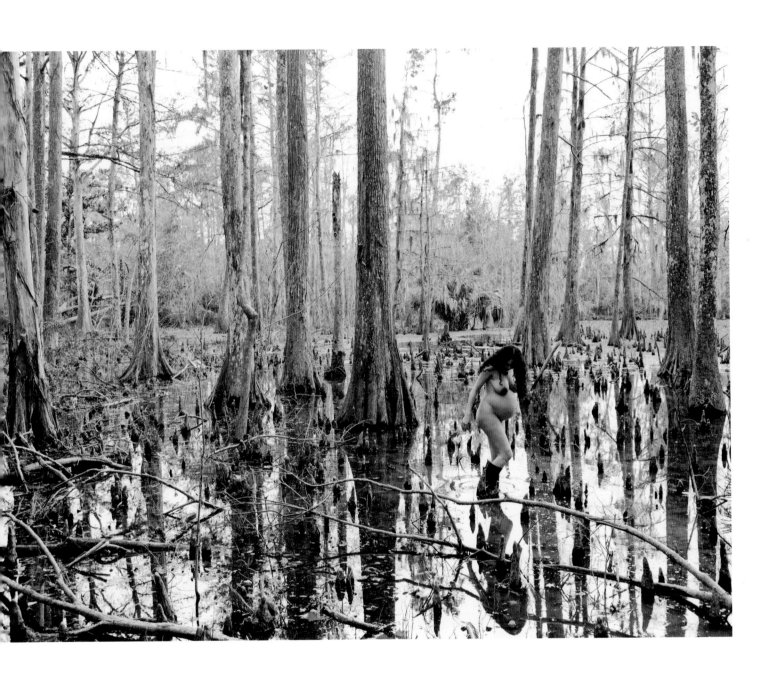

Plate 50.

Justine Kurland. *Wild Palms*, 2006.

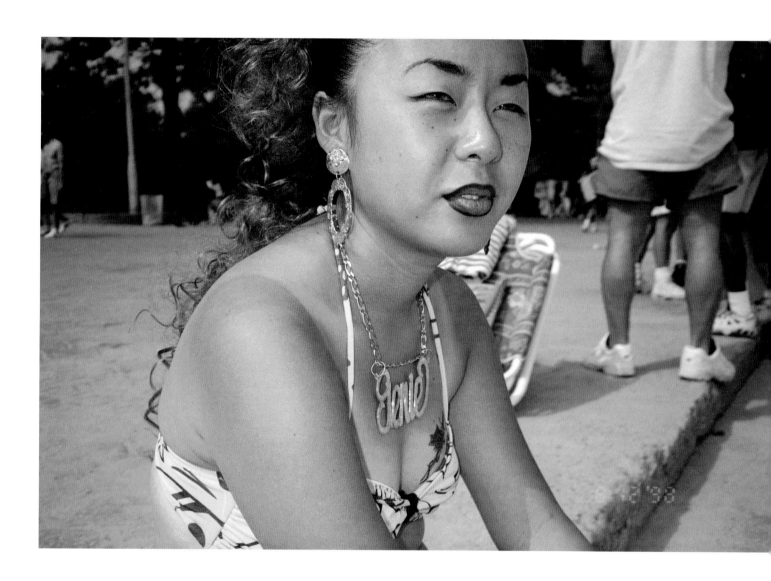

Plate 51.

Nikki S. Lee. *The Hispanic Project (25)*, 1998.

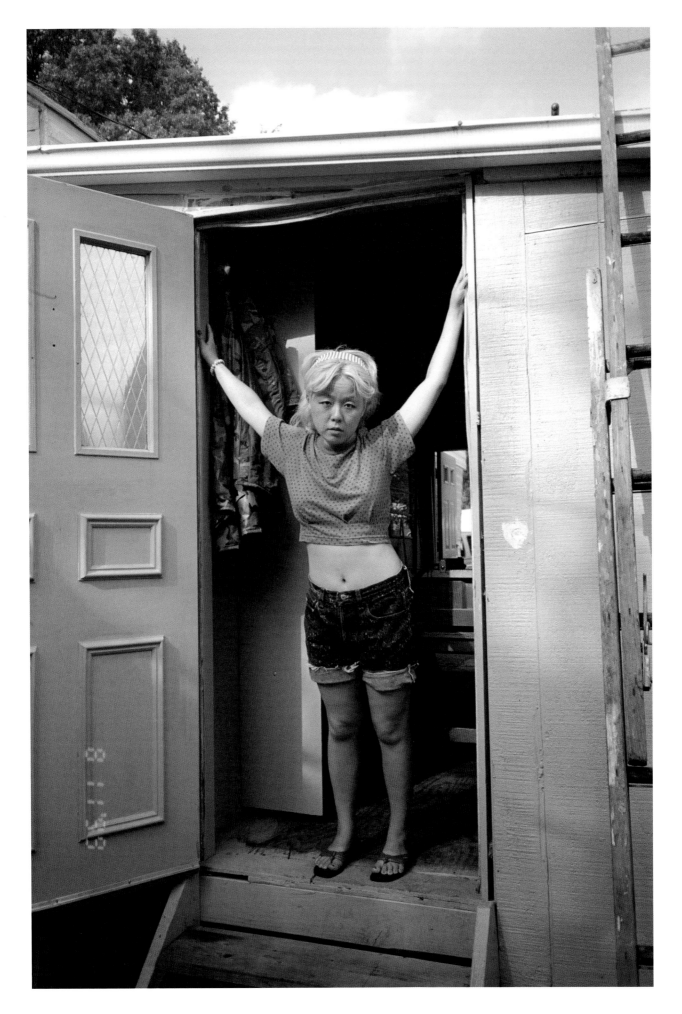

Plate 52.

Nikki S. Lee. The Ohio Project (8), 1999.

105

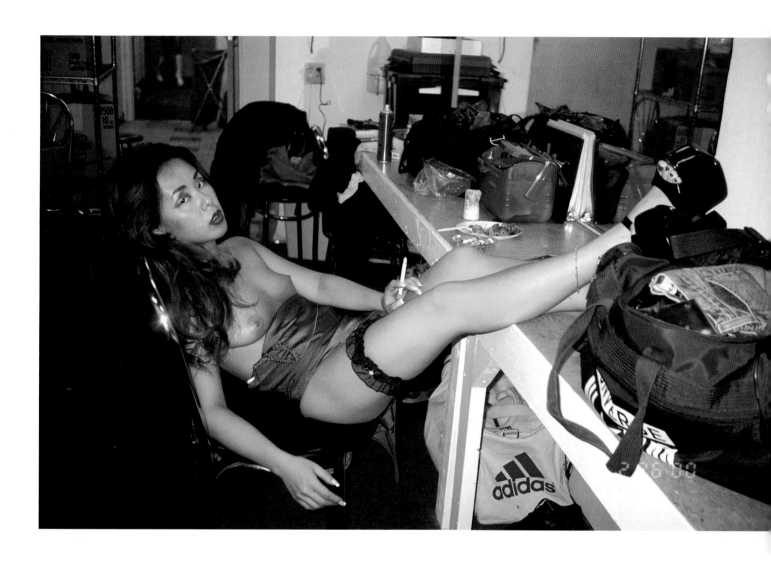

Plate 53.

Nikki S. Lee. *The Exotic Dancer Project (23)*, 2000.

Plate 54.

Nikki S. Lee. *The Hip-Hop Project (36)*, 2002.

107

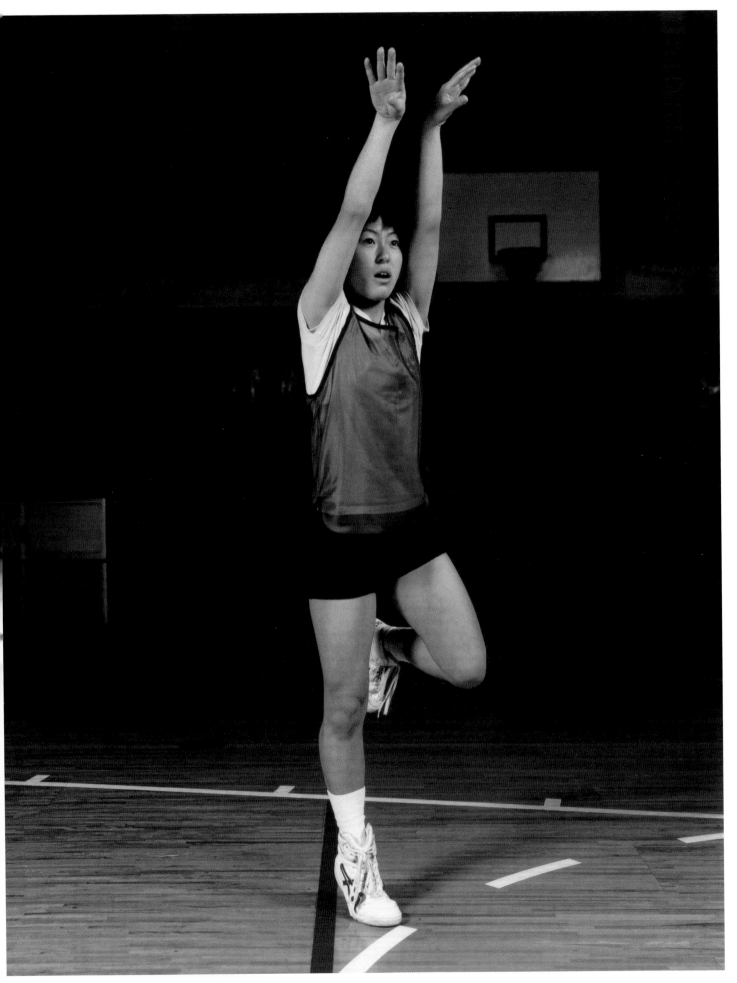

Plate 55.

Sharon Lockhart. Goshogaoka Girls Basketball Team, Group IV:
a) Ayako Sano, 1997.

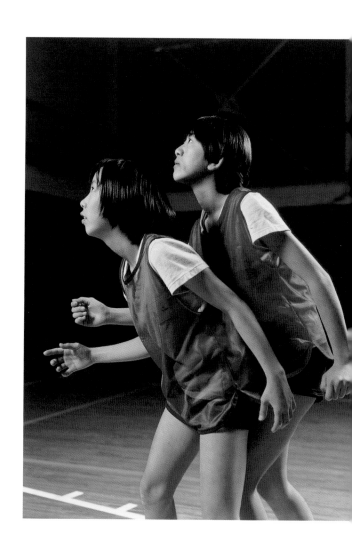

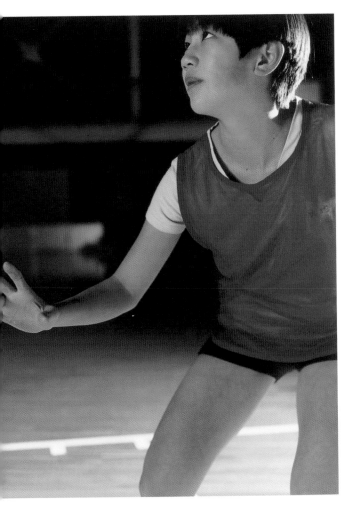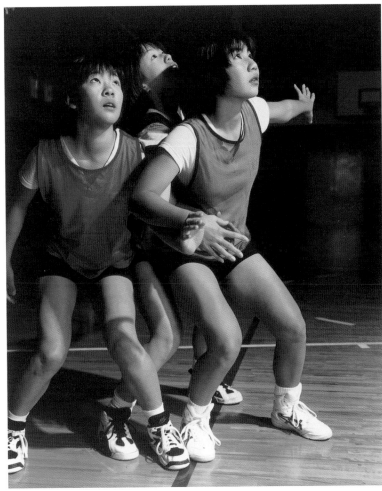

Plate 56.
Sharon Lockhart. *Goshogaoka Girls Basketball Team, Group I:*
a) Kumi Nanjo & Marie Komuro, b) Rie Ouchi, c) Atsuko Shinkai,
Eri Kobayashi and Naomi Hasegawa, 1997.

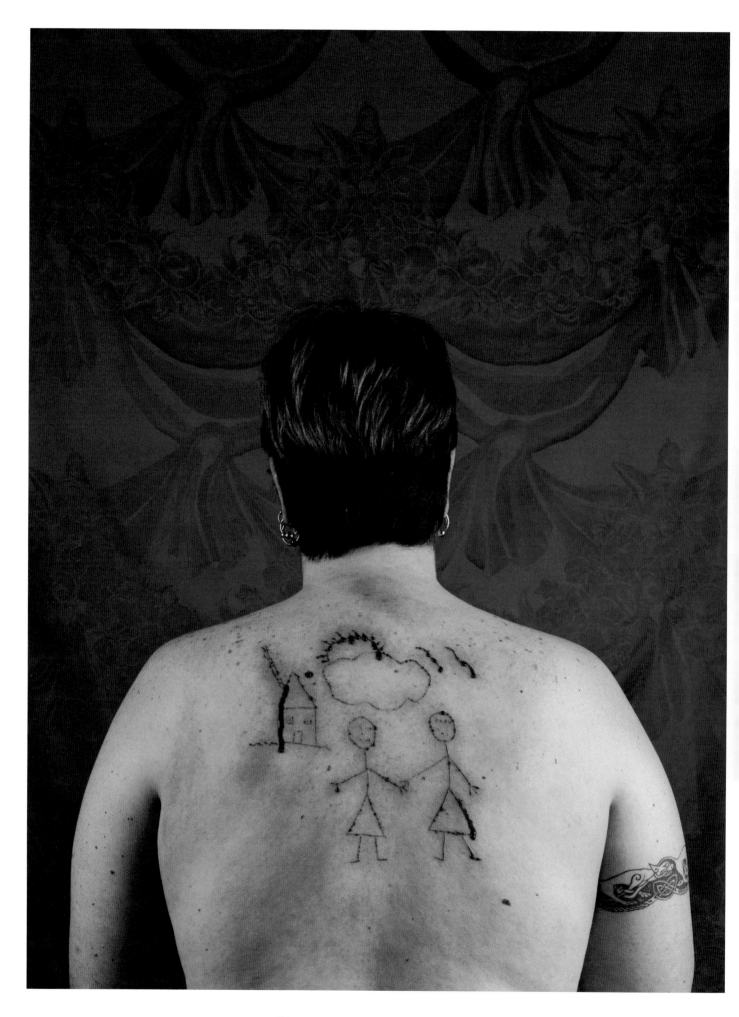

Plate 57.

Catherine Opie. *Self-Portrait/Cutting*, 1993.

112

Plate 58

Catherine Opie. *Flipper, Tanya, Chloe, and Harriet, San Francisco, CA, 1995.*

Plate 59.

Catherine Opie. *Oliver in a tutu,* **2004.**

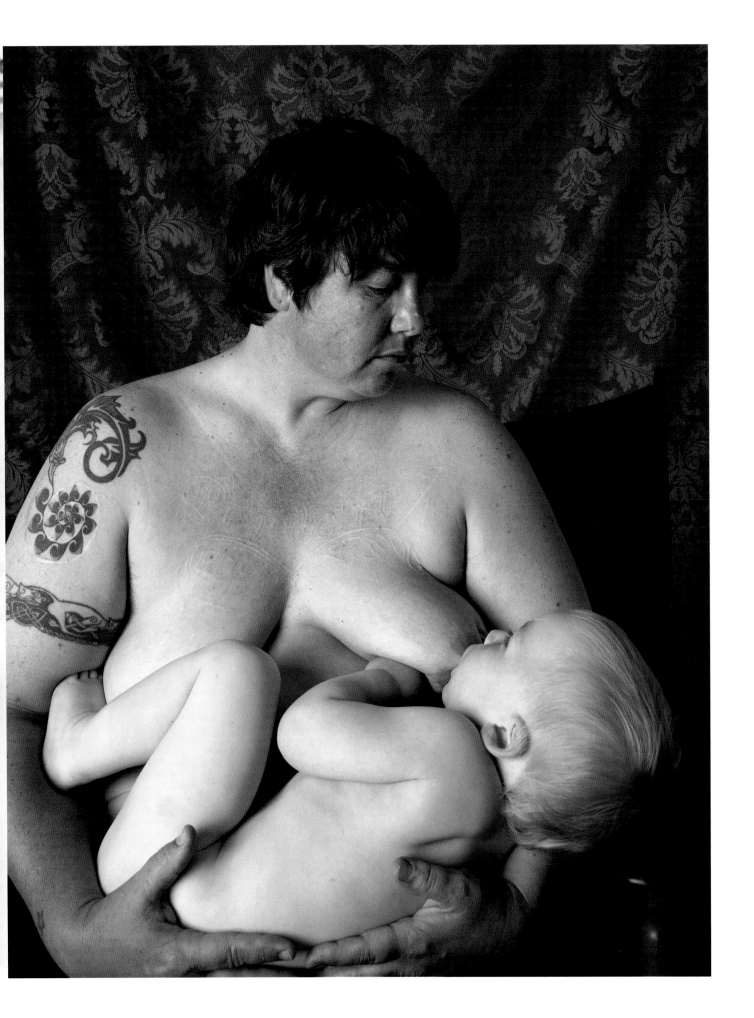

Plate 60.

Catherine Opie. *Self-Portrait/Nursing*, 2004.

Plate 61.

Barbara Probst. *Exposure #24: N.Y.C., Brooklyn Bridge, 12.22.03, 12:16 p.m.*, 2003.

Plate 62.

Barbara Probst. *Exposure #37: N.Y.C., 249 W 34th Street, 11.07.05,*
1:13 pm, 2005.

ON HER KNEES

In finding this one object, I find a world. I think a great painting is a painting that
funnels itself in and then funnels out, spreads out. I enter in a very focused way
and then I go through it and way beyond it.

114 54

ON HER KNEES

115

Plate 63.

Collier Schorr. Jens F. 114/115, 1999–2002.

119

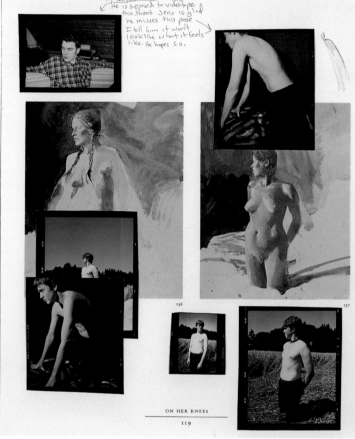

Plate 64.

Collier Schorr. *Jens F. 118/119*, 1999–2002.

OVERFLOW

I thi ▮▮ KODAK 160VC ▮▮ 34 ▮▮ KODAK 160VC ▮▮ 35 e goes.

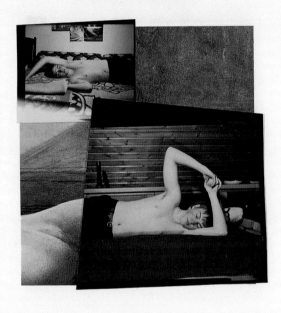

126

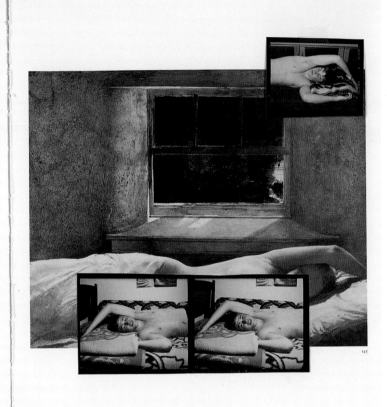

OVERFLOW

127 47

Plate 65.
Collier Schorr. Jens F. 126/127, 1999–2002.

121

Plate 66.

Collier Schorr. *Jens F. 46/47*, 1999–2002.

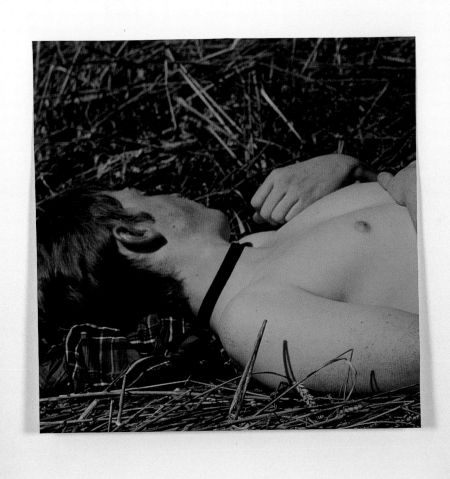

Plate 67.

Collier Schorr. *Cut Field*, 2001–06.

123

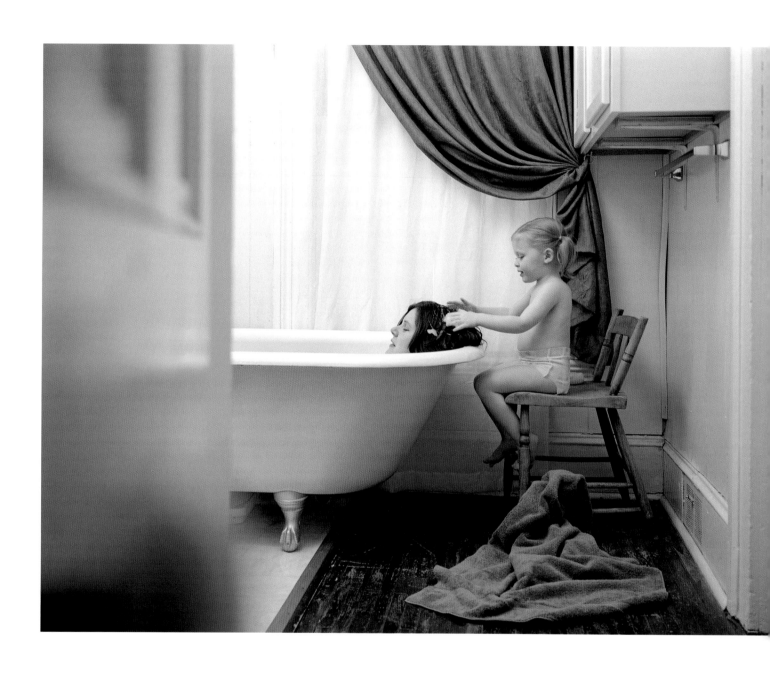

Plate 68.

Angela Strassheim. *Untitled (Yellow Tub)*, 2003.

Plate 60.

Angela Strassheim. *Untitled (Isabel at the Window)*, **2004.**

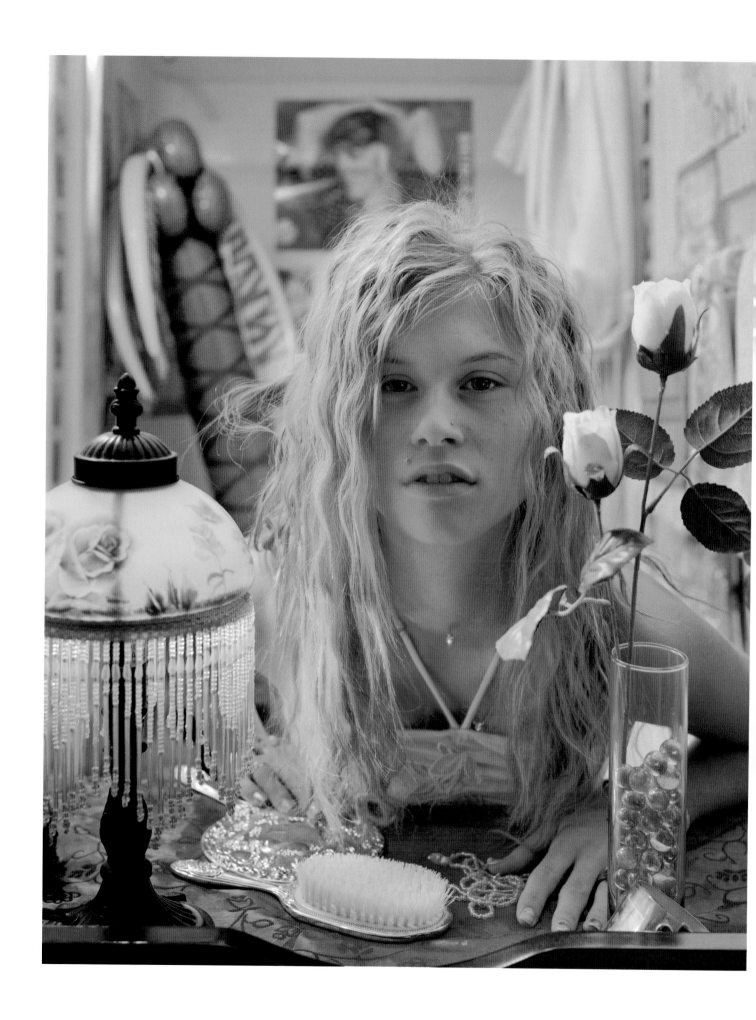

Plate 70.

Angela Strassheim. *Untitled (Miss Emily Jones)*, 2005.

126

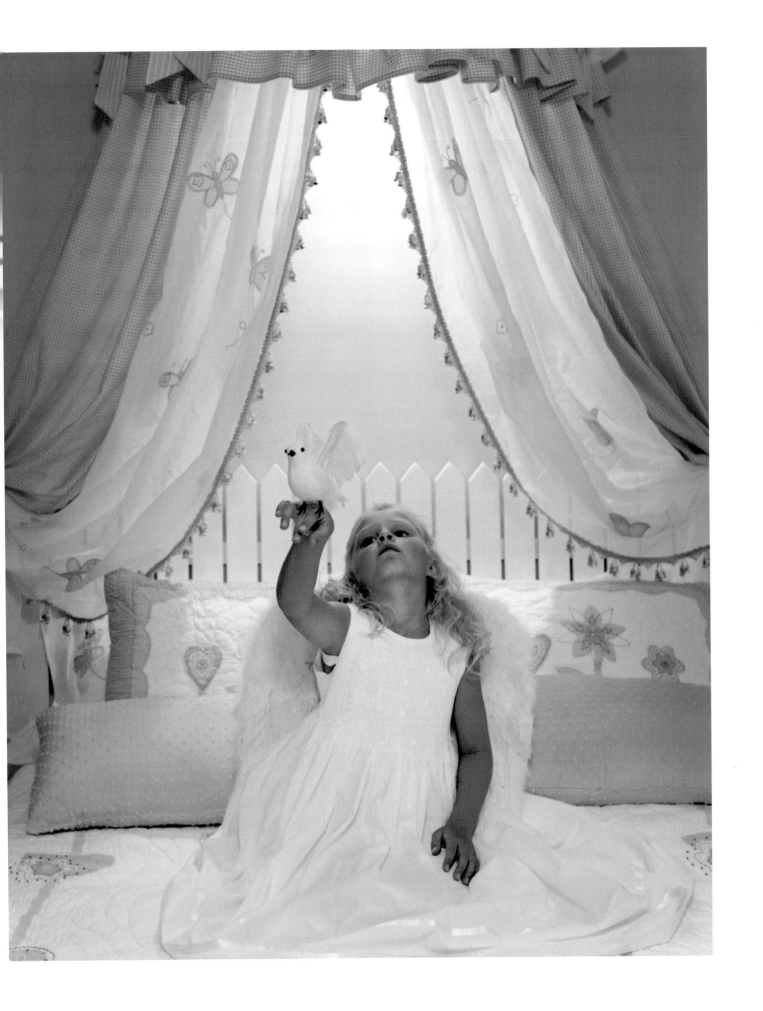

Plate 71.

Angela Strassheim. *Untitled (Nicole with Bird)*, 2006.

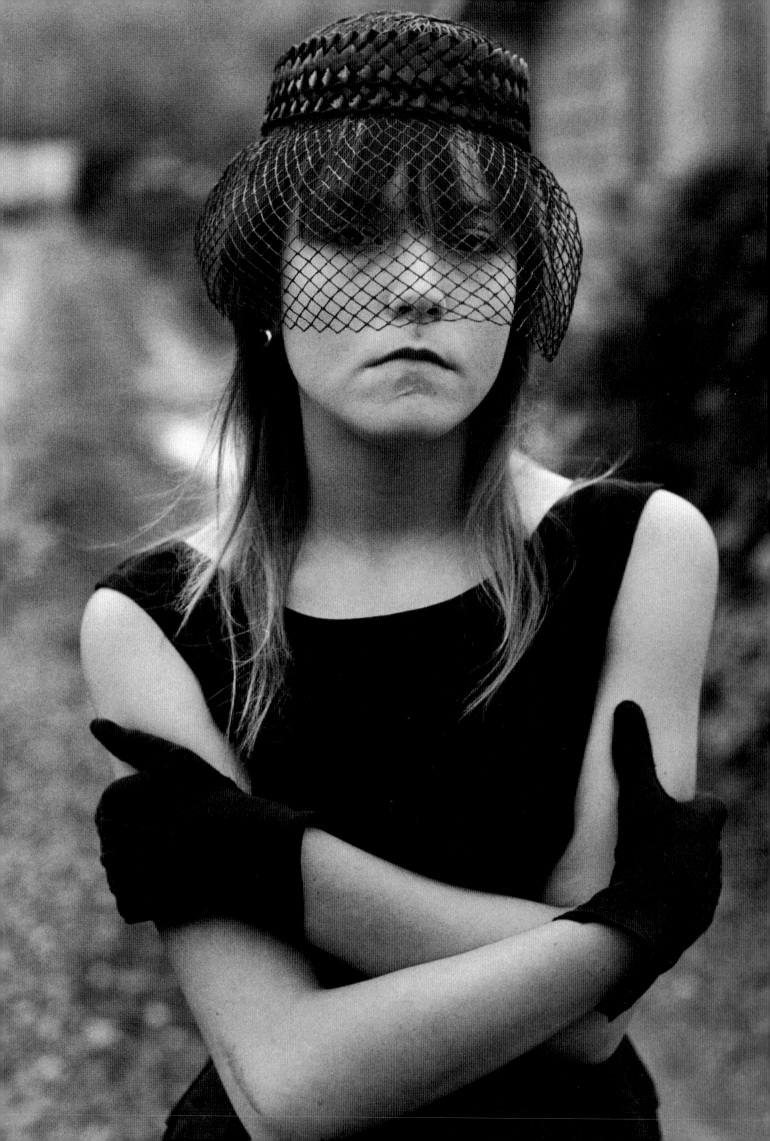

Artist Biographies

ELEANOR ANTIN (b. 1935, New York City) studied acting at Tamara Daykarhanova School for the State, NY, and creative writing at College of the City of New York in the mid-1950s. She lives and works in San Diego. An influential performance artist, photographer, filmmaker, and installation artist, Antin has transformed herself and others using history as an inspiration throughout her career. Exploiting the theatricality of personae and tableaux, Antin helped shift conceptual art practice in the 1970s toward the issues of identity construction and gender roles. The tragically overlooked black ballerina Eleanora Antinova of Diaghilev's Ballet Russes is her most famous persona. For Antin's full resumé, see www.feldmangallery.com.

TINA BARNEY (b. 1945, New York City) studied photography at Sun Valley Center for the Arts and Humanities, Sun Valley, ID, from 1974 to 1983. She lives and works in Watch Hill, RI and New York City. Barney began her photographic career in the late 1970s, working in the street tradition of Cartier-Bresson, but her work soon shifted when she starting using a large-format 4 x 5 inch camera in the early '80s. Creating a new form and relevancy for the family album, she is best known for large-scale portraits of her family and close friends, many of whom are part of New York's and New England's social elite. In her artfully staged images, Barney directs the action to create decisive moments infused with psychological drama and implicit storylines. For Barney's full resumé, see www.janetbordeninc.com.

ANNA GASKELL (b. 1969, Des Moines, IA) studied at Bennington College, Bennington, VT (1990), the Art Institute of Chicago (B.F.A., 1992), and Yale University (M.F.A, 1995). She lives and works in New York City. Since receiving her M.F.A. from Yale, Gaskell has explored femininity by making narrative photographs and films with a film noir edge. Her early work, which is often based in literary sources such as Lewis Carroll's *Alice's Adventures in Wonderland*, features young women dressed in identical uniforms who collectively act out episodic stories. Gaskell carefully directs these photographic fictions about the transition from innocence to experience, including moments of sexual awakening, implied girl-on-girl violence, mystery, and occasionally, joy. For Gaskell's full resumé, see www.yvon-lambert.com.

NAN GOLDIN (b. 1953, Washington, D.C.) studied at Imageworks, Cambridge, MA (1974) and the School of the Museum of Fine Arts/Tufts University, Boston (B.F.A., 1977; fifth year certificate, 1978). She lives and works in New York City, Paris, and London. Goldin came of age as a documentarian, photographing the lives of her circle of friends in Boston's art, gay, and transvestite communities while studying at the School of the Museum of Fine Arts. Moving to New York after graduation, she continued to create images chronicling her involvement with urban subcultures. Often challenging traditional social mores, Goldin positions herself as a full participant in her images that center on gender, sexuality, domesticity, drugs, and violence. Her works became the basis for her slide show, *The Ballad of Sexual Dependency*, 1981–96, followed by the series *All By Myself*, 1995–96, and *I'll Be Your Mirror*, 1997. For Goldin's full resumé, see www.matthewmarks.com.

KATY GRANNAN (b. 1969, Arlington, MA) received her degrees from the University of Pennsylvania (B.A., 1991) and Yale University (M.F.A., 1999). She lives and works in San Francisco. Working in the portrait-photographer mode since 1999, Grannan depicts ordinary people as they wish to be seen. She begins by placing a short ad in a local newspaper asking for models. She interviews the respondents over the phone and then arranges for a photo session in the model's house or environs. Operating in tandem with her subjects to arrive at the poses they desire, Grannan creates images that are often disquieting, or even embarrassing, offering viewers what appears to be the ultimate insider's look. For Grannan's full resumé, see www.gvdgallery.com.

Mary Ellen Mark. *Tiny in Her Halloween Costume, Seattle, 1983.* (detail, Plate 32)

JUSTINE KURLAND (b. 1969, Warsaw, NY) studied at the School of Visual Arts, New York (B.F.A., 1996) and Yale University (M.F.A., 1998). She lives and works in New York City. Influenced by nineteenth-century landscape painting and utopian idealism, Kurland creates large-scale photographs of rural landscapes dotted with figures. Her subjects are typically schoolgirls or adolescents on their own, or commune inhabitants engaged in group activities. Created with an epic cinematic sweep and masterful stagecraft, Kurland's images of women exist somewhere on a continuum between reality and paradise. For Kurland's full resumé, see www.miandn.com.

NIKKI S. LEE (b. Lee Seung-Hee, 1970, Kye-Chang, South Korea) was educated at the Fashion Institute of Technology, New York (B.A., 1994) and New York University (M.F.A., 1998). She lives and works in Seoul, Korea. Lee came to the United States in 1994, adopted the pseudonym Nikki S. Lee, worked as a fashion photographer's assistant, and began her *Projects* series while completing her M.F.A. In her *Projects*, the artist portrays members of different subcultures and social groups, adopting their postures, gestures, dress, and accoutrements. Combining sociology with the snapshot, her chameleon-like performances are convincing and empathetic, while her Korean identity serves as the unifying thread throughout her work. For Lee's full resumé, see www.sikkemajenkinsco.com.

SHARON LOCKHART (b. 1964, Norwood, MA) studied at the San Francisco Art Institute (B.F.A., 1991) and Art Center College of Design, Pasadena, CA (M.F.A., 1993). She lives and works in Los Angeles. Lockhart stages her photographic work using methods reminiscent of filmmaking, while her films emphasize the photographic elements of the moving image. Strongly influenced by structuralist film, her work often deals with the uneasy relationships between stillness and motion, truth and fiction, and the complex documentary traditions of both photography and film. For Lockhart's full resumé, see www.gladstonegallery.com.

SALLY MANN (b. 1951, Lexington, VA) attended Bennington College and World Friends College, before receiving both her B.A. (1974) and M.A. (1975) from Hollins College, Roanoke, VA. She lives and works in Lexington, VA. By the late 1980s, Mann was using an 8 x 10 inch view camera to create powerful series of images centering on the transition from childhood to adolescence. Her photo essay, *At Twelve: Portraits of Young Women*, 1988, presented the varied guises of female adolescence. *Immediate Family*, 1992, featured intimate photographs of her own children and expressively recorded the significance of role-playing in children's developing sexuality and sense of self. For Mann's full resumé, see www.gagosian.com.

MARY ELLEN MARK (b. 1940, Philadelphia) holds a B.A. (1962) and M.A. (1964) from the University of Pennsylvania. She lives and works in New York City. Throughout her career, Mark has documented the lives of those who live at the margins of society: female mental patients, street kids, homeless families, circus performers, rodeo riders, and prostitutes. Eschewing the traditional detachment of social documentarians, Mark often displays a unique empathy for her subjects, including the teenage runaway Tiny, a.k.a. Erin Blackwell, whose life in Seattle, Washington, Mark has shared and recorded in pictures for over twenty years. For Mark's full resumé, see www.maryellenmark.com.

CATHERINE OPIE (b. 1961, Sandusky, OH). Studied at the San Francisco Art Institute (B.F.A., 1985) and California Institute of the Arts, Valencia (M.F.A., 1988). She lives and works in Los Angeles and New York City. While Opie has photographed Southern California's houses, landscapes, freeways, and surfers, she continues to be best known for her compelling self-portraits and images of gay, lesbian, and transgendered acquaintances who are part of her Los Angeles community. Often portrayed against lush backgrounds and in vibrant colors, her subjects direct their gazes at the viewer, thereby turning the table on the traditional social documentation of "outsiders" by predecessors such as Diane Arbus. Through these images, Opie presents the body as a site for aesthetic as well as sexual/gender experimentation. For Opie's full resumé, see www.regenprojects.com.

BARBARA PROBST (b. 1964, Munich, Germany) was educated at the Akademie der Bildenden Künste, Munich, and Staatliche Kunstakademie, Düsseldorf from 1984 to 1990. She lives and works in New York City and Munich. Probst arranges for multiple photographers or cameras to take pictures of the same subject from different distances and angles and at an exact moment. The resulting exposures are diverse in their style, content, and portrayal of the subject, thus emphasizing the rupture between the constructed image and reality and subverting the notion of one point of view. Many of her subjects are young women, posed against neutral studio backdrops and slick urban landscapes. However, rather than describing who these women are or how they relate to their surrounding space, Probst's work points out how both photographers and viewers translate their subject's experience, creating images with disparate spheres of meaning. For Probst's full resumé, see www.gfineartdc.com.

COLLIER SCHORR (b. 1963, New York City) studied at the School of the Visual Arts, New York (B.F.A., 1986). She lives and works in Brooklyn, NY. Schorr's photographs of adolescent men and women often examine the ways in which gender, sexuality, and nationality inflect an individual's identity. In her works that examine femininity and masculinity, Schorr purposefully incorporates ambiguity. She seeks to develop a more nuanced answer to Cindy Sherman's *Untitled Film Stills* and other early '80s works that focused on the mechanisms of gender identification, role-playing, and stereotyping. For Schorr's full resumé, see www.303gallery.com.

CINDY SHERMAN (b. 1954, Glen Ridge, NJ) studied at State University College at Buffalo, NY (B.A., 1976). She lives and works in New York City. Sherman was at the forefront of a new generation of artists in the early 1980s that concentrated on mass media's codes of social and sexual representation, especially regarding feminine identity. Initially working with black-and-white photography, Sherman advanced the concept of narrative photography in her *Untitled Film Stills* of 1977–80. Continuing to use personae, costumes, props, and tableaux in subsequent series in the 1980s and '90s, Sherman's art has appropriated and recast images found in film, television, magazines, and advertising to disrupt stereotypes of women's social roles. For Sherman's full resumé, see www.metropicturesgallery.com.

LAURIE SIMMONS (b. 1949, Long Island, NY) received her degree from the Tyler School of Art, Temple University, Philadelphia (B.F.A., 1971). She lives and works in New York City. Creating staged set-ups with dolls, playhouses, miniature and oversized furnishings, fashion accessories, ventriloquist dummies, and other props, Simmons' photographs since the late 1970s have explored the restrictive nature of women's lives and domesticity within American bourgeois culture. Ranging from comfortably familiar to highly dramatic, Simmons' images of dolls and puppets are meant to stand in for real people, revealing their struggle with everyday desires for status, recognition, and financial success. For Simmons' full resumé, see www.speronewestwater.com.

LORNA SIMPSON (b. 1960, Brooklyn, NY) studied at the School of the Visual Arts, New York (B.F.A., 1982) and the University of California, San Diego (M.F.A., 1985). She lives and works in Brooklyn, NY. Since the 1980s, Simpson has explored the interface between words and images to express ideas about social detachment, forbidden sexuality, and African American experience. Her photographs, installations, and films most often depict female figures, including herself, facing away from the camera or engaged in a routine activity that frustrates the voyeur's gaze. Her images have a spare metaphorical elegance but allude sharply to historical and contemporary social forces that shape black female identity in the U.S. For Simpson's full resumé, see www.salon94.com

ANGELA STRASSHEIM (b. 1969, Bloomfield, IA) holds degrees from the Minneapolis College of Art and Design (B.F.A., 1995) and Yale University (M.F.A., 2003) as well as a Forensic and Biomedical Photography Certification (1997) from the Forensic Imaging Bureau, Metro-Dade County, Miami, FL. She lives and works in New York City and Minneapolis. Strassheim's socially loaded portraiture and girl-culture narratives reveal how the experience of growing up female in a religious family can profoundly influence one's artistic vision. Featuring stage-like, candy-colored rooms, Strassheim's images reflect both the realities and fantasies of white suburban middle America. The lessons of forensics also continue to be evident in the sharp detail, clinical lighting, and detachment of Strassheim's carefully composed works. For Strassheim's full resumé, see www.marvelligallery.com.

CARRIE MAE WEEMS (b. 1953, Portland, OR) studied at the California Institute of the Arts, Valencia (B.F.A., 1981), the University of California, San Diego (M.F.A., 1984), and the University of California, Berkeley. She lives and works in Syracuse, NY and Brooklyn, NY. Part storyteller, folklorist, and image-maker, Weems reframes American social history by finding black experience within its mainstream. Moving in the 1980s from documentary photography to conceptual photography, sculpture, sound, video, and film work, Weems is best known for integrating images and texts to document and challenge perceptions of race, class, and gender. While she typically uses black subjects in her art and deals powerfully with African American heritage, her images are meant to represent diverse ethnicities and social experiences. For Weems' full resumé, see www.jackshainman.com.

Exhibition Checklist

ELEANOR ANTIN

The Angel of Mercy, from *The Angel of Mercy*, 1977
Tinted gelatin silver print mounted on paper
6½ x 8½ inches
Purchase, with funds from Joanne Leonhardt
Cassullo and the Photography Committee 95.68.1
Whitney Museum of American Art, New York

In the Trenches before Sebastopol, from
The Angel of Mercy, 1977
Tinted gelatin silver print mounted on paper
10 x 12 inches
Purchase, with funds from Joanne Leonhardt
Cassullo and the Photography Committee 95.68.32
Whitney Museum of American Art, New York

Recollections of My Life with Diaghilev 1919–1929,
1976–78
Portfolio of five tinted silver gelatin photographs on
hard paper; two watercolor, pen, and ink drawings
from "Paris Life" series; and six text panels (one
page per ballet and title page)
Seven images, 14 x 11 inches each
Six texts, 14 x 11¼ inches each
Courtesy of the artist and Ronald Feldman Fine Arts,
New York

TINA BARNEY

Jill and Polly in the Bathroom, 1987
Chromogenic print
48 x 60 inches
Courtesy of the artist and Janet Borden, Inc.

Marina's Room, 1987
Ektacolor Plus print
48 x 60 inches
Smithsonian American Art Museum, Museum
purchase

Thanksgiving, 1992
Chromogenic print
48 x 60 inches
Courtesy of the artist and Janet Borden, Inc.,
New York

ANNA GASKELL

untitled #2 (wonder), 1996
Chromogenic print
60 x 50 inches
Collection of Debra and Dennis Scholl, Miami Beach

untitled #6 (wonder), 1996
Chromogenic print
20 x 24 inches
Heather and Tony Podesta Collection,
Washington, D.C.

untitled #25 (override), 1997
Chromogenic print laminated and mounted on
Sintra
19⅞ x 15½ inches
Collection of Lorenzo Rodriguez, New York

untitled #26 (override), 1997
Chromogenic print
19⅜ x 23⅝ inches
Heather and Tony Podesta Collection,
Washington, D.C.

untitled #69 (by proxy), 1999
Chromogenic print
20 x 24 inches
Gift of Heather and Tony Podesta Collection,
Washington, D.C.
National Museum of Women in the Arts,
Washington, D.C.

NAN GOLDIN

Self-portrait in kimono with Brian, NYC, 1983
Cibachrome print
27 x 39¾ inches
Promised Gift of Steven Scott, Baltimore, in honor of
the National Museum of Women in the Arts' tenth
anniversary
National Museum of Women in the Arts,
Washington, D.C.

Cookie in the NY inferno, NYC, 1985
Cibachrome print
24 x 20 inches
Promised Gift of Steven Scott, Baltimore, in honor
the artist
National Museum of Women in the Arts,
Washington, D.C.

Misty and Jimmy Paulette in a taxi, NYC, 1991
Cibachrome print
30 x 40 inches
Courtesy of the artist and Matthew Marks Gallery
New York

Joey in my mirror, Berlin, 1992
Cibachrome print
30 x 40 inches
Courtesy of the artist and Matthew Marks Gallery
New York

Self-portrait on my bed, Berlin, 1994
Cibachrome print
30 x 41 inches
On loan from Dr. Michael I. Jacobs, New York

KATY GRANNAN

Untitled (from *The Poughkeepsie Journal*), 1998
Chromogenic print
46¼ x 37 inches
Heather and Tony Podesta Collection,
Washington, D.C.

Pleasant Valley, NY, 2002
Chromogenic print
45 x 35½ inches
Gift of Heather and Tony Podesta Collection,
Washington, D.C.
National Museum of Women in the Arts,
Washington, D.C.

Taryn & Bird, Pinardville, NH, 2003
Gelatin silver print
20 x 16 inches
Collection of Nicolas Rohatyn and Jeanne
Greenberg Rohatyn, New York

JUSTINE KURLAND

Cyclone, 2001
Satin finish UV-laminated chromogenic print
mounted on Sintra
30 x 40 inches
Heather and Tony Podesta Collection,
Washington, D.C.

The Pale Serpent, 2003
Chromogenic print
40 x 50 inches
Collection of Melva Bucksbaum and
Raymond Learsy

Self-Portrait with Casper, Texas Canyon, 2006
Chromogenic print
20 x 23⅛ inches
Heather and Tony Podesta Collection,
Washington, D.C.

Wild Palms, 2006
Chromogenic print
30 x 40 inches
Courtesy of Mitchell-Innes & Nash, New York

NIKKI S. LEE

The Hispanic Project (25), 1998
Fujiflex print mounted on Sintra
30 x 40 inches
Heather and Tony Podesta Collection,
Washington, D.C.

The Ohio Project (8), 1999
Fujiflex print
40 x 30 inches
Heather and Tony Podesta Collection,
Washington, D.C.

The Exotic Dancer Project (23), 2000
Fujiflex print
30 x 40 inches
Heather and Tony Podesta Collection,
Washington, D.C.

The Hip-Hop Project (36), 2002
Fujiflex print
21⅜ x 28⅜ inches
The Collection of Francine Farr, Washington, D.C.

SHARON LOCKHART

*Goshogaoka Girls Basketball Team, Group IV:
a) Ayako Sano*, 1997
Chromogenic print
44¾ x 37¾ inches
Gift of Heather and Tony Podesta Collection,
Falls Church, Virginia 2006.159.18
National Gallery of Art, Washington, D.C.

*Goshogaoka Girls Basketball Team, Group I:
a) Kumi Nanjo & Marie Komuro, b) Rie Ouchi,
c) Atsuko Shinkai, Eri Kobayashi and Namoi
Hasegawa*, 1997
Set of three chromogenic prints
32⁵⁄₁₆ x 98¼ inches
Gift of Heather and Tony Podesta Collection,
Falls Church, Virginia 2006.159.11–13
National Gallery of Art, Washington, D.C.

SALLY MANN

Lithe and the Birthday Cake, 1983–85
Gelatin silver print
8 x 10 inches
Courtesy of the artist and Gagosian Gallery,
New York

Juliet in the White Chair, 1983–85
Gelatin silver print
8 x 10 inches
Courtesy of the artist and Gagosian Gallery,
New York

Untitled (Seith), 1984
Gelatin silver print
9¹⁵⁄₁₆ x 8 inches
Museum purchase 1990.56
Addison Gallery of American Art, Phillips Academy,
Andover, Massachusetts
(not illustrated)

Jessie at 5, 1987
Gelatin silver print
8 x 10 inches
Museum purchase 1990.62
Addison Gallery of American Art, Phillips Academy,
Andover, Massachusetts

Gorjus, 1989
Gelatin silver print
20 x 24 inches
Courtesy of the artist and Gagosian Gallery,
New York

Hayhook, 1989
Gelatin silver print
20 x 24 inches
Courtesy of the artist and Gagosian Gallery,
New York

MARY ELLEN MARK

Lillie with Her Rag Doll, Seattle, 1983
Gelatin silver print
8⅞ x 13⅜ inches
The J. Paul Getty Museum, Los Angeles

Patti and Munchkin, Seattle, 1983
Gelatin silver print
8⅛ x 12¹⁄₁₆ inches
The J. Paul Getty Museum, Los Angeles

Tiny in Her Halloween Costume, Seattle, 1983
Gelatin silver print
11 x 14 inches
Courtesy of the artist and the Mary Ellen Mark
Library/Studio

Tiny in the Park, Seattle, 1983
Gelatin silver print
8⅞ x 13¾ inches
The J. Paul Getty Museum, Los Angeles

Tiny and Her Mother Fighting, Seattle, 1999
Gelatin silver print
11 x 14 inches
Courtesy of the artist and the Mary Ellen Mark
Library/Studio

*Tiny in the Bathroom with Ray Shon and Tyrese,
Seattle*, 2003
Gelatin silver print
11 x 14 inches
Courtesy of the artist and the Mary Ellen Mark
Library/Studio

CATHERINE OPIE

Self-Portrait/Cutting, 1993
Chromogenic print
41 x 31 inches
Collections of Peter Norton and Eileen Harris
Norton, Santa Monica

*Flipper, Tanya, Chloe, and Harriet, San Francisco,
CA*, 1995
Chromogenic print
40 x 50 inches
The Collection of Scott Lorinsky, New York

Oliver in a tutu, 2004
Chromogenic print
24 x 20 inches
Private collection, Los Angeles

Self-Portrait/Nursing, 2004
Chromogenic print
40 x 32 inches
Private collection, Los Angeles

BARBARA PROBST

*Exposure #24: N.Y.C., Brooklyn Bridge, 12.22.03,
12:16 p.m.*, 2003
Ultrachrome ink on cotton paper
Two parts: 30½ x 20½ inches each
Courtesy of Murray Guy Gallery, New York and
G Fine Art, Washington, D.C.

*Exposure #37: N.Y.C., 249 W 34th Street,
11.07.05, 1:13 pm*, 2005
Ultrachrome ink on cotton paper
Two parts: 74½ x 49½ inches each
Collection of Fran and Leonard Tessler

COLLIER SCHORR

Jens F. 114/115, 1999–2002
Photo collage
11 x 19 inches
Courtesy of 303 Gallery, New York and Stuart
Shave/Modern Art, London

Jens F. 118/119, 1999–2002
Photo collage
11 x 19 inches
Courtesy of 303 Gallery, New York and Stuart
Shave/Modern Art, London

Jens F. 126/127, 1999–2002
Photo collage
11 x 19 inches
Courtesy of 303 Gallery, New York and Stuart
Shave/Modern Art, London

Jens F. 46/47, 1999–2002
Photo collage
11 x 19 inches
Courtesy of 303 Gallery, New York and Stuart
Shave/Modern Art, London

Cut Field, 2001–06
Chromogenic print
15½ x 15½ inches
Courtesy of 303 Gallery, New York and Stuart
Shave/Modern Art, London

CINDY SHERMAN

Untitled #96, 1981
Chromogenic print
23¹⁵⁄₁₆ x 47¹⁵⁄₁₆ inches
(not in exhibition)

Untitled #112, 1982
Chromogenic print
45¼ x 30 inches
(not in exhibition)

Untitled #131, 1983
Chromogenic print
35 x 16½ inches
(not in exhibition)

Untitled #205, 1989
Chromogenic print
53½ x 40¼ inches
(not in exhibition)

Untitled (Lucy, 1975), printed 2001
Sepia-toned crystal archive print
11 x 14 inches
Promised gift of Steven Scott, Baltimore, in honor
of the artist: National Museum of Women in the
Arts, Washington, D.C.
(not illustrated)

Untitled, 1980
Cibachrome print
20 x 24 inches
Promised gift of Steven Scott, Baltimore: National
Museum of Women in the Arts, Washington, D.C.
(not illustrated)

LAURIE SIMMONS

Blonde/Red Dress/Kitchen, 1978
Cibachrome print
3½ x 5 inches
Courtesy of Sperone Westwater, New York

Pushing Lipstick (Full Profile), 1979
Cibachrome print
5¾ x 8¾ inches
Courtesy of the artist and Sperone Westwater,
New York

Woman/Green Shirt/Red Barn, 1979
Cibachrome print
5 x 7¼ inches
Courtesy of the artist and Sperone Westwater,
New York

Suzie Swine, 1987
Cibachrome print
35 x 25 inches
Courtesy of the artist and Sperone Westwater,
New York

Walking Cake II, 1989
Cibachrome print
69⅜ x 51⅜ inches
Private collection

Music of Regret IV (color), 1994
Cibachrome print
19½ x 19½ inches
Promised gift of Steven Scott, Baltimore, in honor
of Susan Fisher Sterling, NMWA Curator of Modern
and Contemporary Art
National Museum of Women in the Arts,
Washington, D.C.

LORNA SIMPSON

Waterbearer, 1986
Gelatin silver print and plastic letters
41¾ x 79¼ x 2¼ inches
(not in exhibition)

Coiffure, 1991
Three gelatin silver prints and ten engraved
plastic plaques
72 x 106 inches
Museum purchase; prior gifts of James Turner,
Mrs. Walter S. Marvin, Charles W. Hamilton and
Acquisition Fund 1996.9a–m
Montclair Art Museum, Montclair, New Jersey

She, 1992
Four Polaroid prints and one engraved plaque
29 x 85¼ inches
Collection of Jack and Sandra Guthman

ANGELA STRASSHEIM

Untitled (Yellow Tub), 2003
Chromogenic print
30 x 40 inches
Courtesy of Marvelli Gallery, New York

Untitled (Isabel at the Window), 2004
Chromogenic print
40 x 50 inches
Heather and Tony Podesta Collection,
Washington, D.C.

Untitled (Miss Emily Jones), 2005
Chromogenic print
40 x 30 inches
Heather and Tony Podesta Collection,
Washington, D.C.

Untitled (Nicole with Bird), 2006
Chromogenic print
40 x 30 inches
Heather and Tony Podesta Collection,
Washington, D.C.

CARRIE MAE WEEMS

Untitled (Woman with daughter), from Kitchen
Table Series, 1990
Three gelatin silver prints
27¼ x 27¼ inches each
Gift of the Contemporary Art Council
Portland Art Museum, Portland, Oregon

*From Here I Saw What Happened and I Cried
(House/Field/Yard/Kitchen)*, 1995–96
Four monochromatic chromogenic prints with
sandblasted text on glass
26½ x 22¾ inches each
Courtesy of the artist and Jack Shainman Gallery,
New York

After Manet, from the series *May Days Long
Forgotten*, 2003
Chromogenic print, wood, and convex glass
33³⁄₁₆ inches in diameter
The J. Paul Getty Museum, Los Angeles

COLLECTION CREDITS

The following institutions have supplied photographs of works in their collections for which repository is not noted elsewhere:

Akron Art Museum, OH: Carrie Mae Weems, *Untitled* (Woman with friends), from the Kitchen Table Series, 1990, Knight Purchase Fund for Photographic Media, 1996.4 a-c, p. 39

Art Institute of Chicago: Diane Arbus, *A Family On Their Lawn One Sunday in Westchester, New York,* 1968, Gift of Richard Avedon, 1986.2977, p. 15

Cleveland Museum of Art, OH: Sally Mann, *Jessie at 5,* 1987, John L. Severance Fund, 2000.87, p. 77

Corcoran Gallery of Art, Washington, D.C.: Lorna Simpson, *Coiffure,* 1991, Gift of the Women's Committee of the Corcoran Gallery of Art, 1993.1.3.a-m, p. 68

Knoxville Museum of Art, TN: Sally Mann, *Juliet in the White Chair,* 1983-85, p. 76

Maier Museum of Art, Randolph College, Lynchburg, VA: Sally Mann, *The New Mothers,* 1989, Purchase made possible by the Louise Jordan Smith Fund, 1991, M.1991.13, p. 38

National Museum of Women in the Arts, Washington, D.C.: Gertrude Käsebier, *The Manger,* c. 1899, Gift of the Holladay Foundation, p. 13

Solomon R. Guggenheim Museum, New York: Anna Gaskell, *untitled #6 (wonder),* 1996, Purchased with funds contributed by the Young Collector's Council, 1997, 97.4581, pp. cover, 92

REPRODUCTION AND PHOTOGRAPH CREDITS

courtesy 303 Gallery, New York: pp. 119–123; courtesy Akron Art Museum, OH: p. 39; © Eleanor Antin, courtesy Ronald Feldman Fine Arts, New York: pp. 17, 37, 56–61; © 1968 The Estate of Diane Arbus, LLC: p. 15; Art Institute of Chicago, photo by RIP* Located in Photo Archive: p. 15; courtesy Cass Bird: p. 32; © Cleveland Museum of Art, OH: p. 77; Corcoran Gallery of Art, Washington, D.C.: p. 68; courtesy Rineke Dijkstra and Marian Goodman Gallery, New York: pp. 24, 25; courtesy G Fine Art, Washington, D.C.: pp. 41, 116, 117; © Anna Gaskell, courtesy Anna Gaskell and Yvon Lambert, New York, Paris: pp. cover, 91–95; © Nan Goldin, courtesy Matthew Marks Gallery, New York: pp. 34, 51–55; courtesy Katy Grannan and Greenberg Van Doren Gallery, New York: pp. 97–99; photo © Lauren Greenfield/VII, courtesy of Pace/MacGill Gallery, New York: p. 36; courtesy Jack Shainman Gallery, New York: pp. 10, 30, 87–89; courtesy Janet Borden, Inc., New York: pp. 16, 71–73; courtesy Shigeyuki Kihara and Sherman Galleries, Sydney: p. 29 top; Knoxville Museum of Art, TN: p. 76; © Sharon Lockhart: pp. 109–111; Maier Museum of Art, Randolph College, Lynchburg, VA: p. 38; courtesy Sally Mann and Gagosian Gallery, New York: pp. 38, 75–79; courtesy Mary Ellen Mark: pp. 80–85, 128; courtesy Marvelli Gallery, New York: pp. 6, 124–127; courtesy Mitchell-Innes & Nash, New York: pp. 100–103; courtesy Mariko Mori and Deitch Projects, New York: p. 31 bottom right; courtesy Orlan and Stefan Stux Gallery, New York: p. 28; courtesy Rachel Papo: p. 31 top left; courtesy Regen Projects, Los Angeles: pp. 112–115; courtesy Tracey Rose and The Project, New York: p. 29 middle; courtesy Michelle Sank: p. 42; courtesy Cindy Sherman and Metro Pictures, New York: pp. 22, 46–49; courtesy Sikkema Jenkins & Co., New York: pp. 2, 29 bottom, 104–107; courtesy Laurie Simmons and Sperone Westwater, New York: pp. 62–65; courtesy Lorna Simpson and Salon 94, New York: pp. 67–69; Solomon R. Guggenheim Museum, New York: pp. cover, 92; courtesy of Jack Shainman Gallery, New York: pp. 10–11, 39, 87–89